by the same author

FICTION

The Joke
Laughable Loves
Life is Elsewhere
Farewell Waltz
The Book of Laughter and Forgetting
The Unbearable Lightness of Being
Immortality
Slowness
Identity
Ignorance

NON-FICTION

The Art of the Novel
Testaments Betrayed
The Curtain

PLAYS

Jacques and his Master

ABOUT THE WORK OF MILAN KUNDERA

Agnès's Final Afternoon
BY FRANÇOIS RICARD

MILAN KUNDERA

ENCOUNTER

———

Translated from the French
by Linda Asher

faber and faber

First published in French in 2009 as *Une Rencontre*
by Éditions Gallimard

First published in English translation in the USA in 2010
by HarperCollins Publishers
10 East 53rd Street,
New York, NY 10022

First published in Great Britain in 2010
by Faber and Faber Limited
Bloomsbury House,
74–77 Great Russell Street,
London WC1B 3DA

Printed in England by TJ International Ltd, Padstow, Cornwall

A CIP record for this book
is available from the British Library

ISBN 978-0-571-25089-9

2 4 6 8 10 9 7 5 3 1

. . . an encounter with my reflections and my recollections,
my old themes (existential and aesthetic) and my old loves . . .

CONTENTS

Contents

I.

THE PAINTER'S BRUTAL GESTURE:
ON FRANCIS BACON

1

WHEN MICHEL ARCHIMBAUD WAS PLANNING A BOOK OF
Francis Bacon's portraits and self-portraits, he asked me to
write a short essay for it. He assured me that the invitation
was Bacon's own wish. He reminded me of a short piece I had
published a long while back in the periodical *L'Arc*, a piece he
said the painter considered one of the few in which he rec-
ognized himself. I will not deny my pleasure at this message,
arriving years later, from an artist I have never met and whom
I so admired.

That piece in *L'Arc* discussed Bacon's triptych of portraits of
Henrietta Moraes; I wrote it in the very first years after I emi-
grated to France, still obsessed by recollections of the country
which I had just left and which still remained in my memory as
a land of interrogations and surveillance. Some eighteen years
later, I can only begin my new consideration of Bacon's art with
that older text from 1977:

2

"IT WAS 1972. I MET WITH A GIRL IN A PRAGUE SUBURB,
in a borrowed apartment. Two days earlier, over an entire day, she
had been interrogated by the police about me. Now she wanted

to meet with me secretly (she feared that she was constantly followed) to tell me what questions they had asked her and how she had answered them. If they were to interrogate me, my answers should match hers.

"She was a very young girl who had little experience of the world as yet. The interrogation had disturbed her, and three days later the fear was still upsetting her bowels. She was very pale, and during our conversation she kept leaving the room to go to the toilet, so our whole encounter was accompanied by the noise of the water refilling the tank.

"I had known her for a long time. She was intelligent and spirited, she was very skilled at controlling her emotions, and was always so impeccably dressed that her outfit, like her behavior, allowed no hint of nakedness. And now suddenly, like a great knife, fear had laid her open. She was gaping wide before me like the split carcass of a heifer hanging from a meat hook.

"The noise of the water refilling the toilet tank practically never let up, and I suddenly had the urge to rape her. I know what I'm saying: 'rape her,' not 'make love to her.' I didn't want tenderness from her. I wanted to bring my hand down brutally on her face and in one swift instant take her completely, with all her unbearably arousing contradictions: with her impeccable outfit along with her rebellious gut, her good sense along with her fear, her pride along with her misery. I sensed that all those contradictions concealed her essence: that treasure, that gold nugget, that diamond hidden in the depths. I wanted to possess her, in one swift second, with her shit and her ineffable soul. But I saw those two eyes staring at me, filled with torment (two tormented eyes in a sensible face), and the more

4

tormented those eyes the more my desire became absurd, stupid, scandalous, incomprehensible, and impossible to carry out.

"Uncalled for and unconscionable, that desire was nonetheless real. I cannot disavow it, and when I look at Francis Bacon's portrait-triptych it's as if I recall it. The painter's gaze comes down on the face like a brutal hand trying to seize hold of her essence, of that diamond hidden in the depths. Of course we are not certain that the depths really do conceal something—but in any case we each have in us that brutal gesture, that hand movement that roughs up another person's face in hopes of finding, in it and behind it, something that is hidden there."

3

THE BEST COMMENTARIES ON BACON'S WORK ARE BY BACON himself in two long interviews: with David Sylvester in 1976 and with Archimbaud in 1992. In both he speaks admiringly of Picasso, especially of the 1926–32 period, the only one to which he feels truly close; he saw an area open there "which has not been explored: an *organic form* that relates to the *human image* but is a *complete distortion* of it" (the emphases are mine).

Aside from that short period, one could say that everywhere else in Picasso, it is the painter's *light gesture* that transformed elements of the human body into a *two-dimensional* form exempt from any obligation to resemble. With Bacon, playful Picassian euphoria is replaced by amazement (if not by terror) at what we are—what we are materially, physically. Impelled by that terror,

the painter's hand (to use the words of my old piece) comes down with a "brutal gesture" on a body, on a face, "in hopes of finding, in it and behind it, something that is hidden there."

But what is hidden there? Its "self"? Certainly every portrait ever painted seeks to uncover the subject's "self." But Bacon lives in a time when the "self" has everywhere begun to take cover. Indeed, our most commonplace personal experience teaches us (especially if the life behind us is very long) that faces are lamentably alike (the insane demographic avalanche further augmenting that feeling), that they are easily confused, that they differ one from the next only by something very tiny, barely perceptible, which mathematically often represents barely a few millimeters' difference in the arrangement of proportions. Add to that our historical experience, which teaches us that men imitate one another, that their attitudes are statistically calculable, their opinions manipulable, and that man is therefore less an individual (a subject) than an element in a mass.

It is in this moment of uncertainty that the rapist hand of the painter comes down with a "brutal gesture" on his models' faces in order to find, somewhere in the depths, their buried self. In this Baconian quest the forms subjected to "a complete distortion" never lose the character of living organisms, they recall their bodily existence, their flesh, they always retain their *three-dimensional* nature. And moreover they look like their models! But how can the portrait resemble the model of which it is intentionally a distortion? Yet photos of the persons portrayed are the proof: it does resemble him or

her; look at the triptychs—three juxtaposed variations on the portrait of the same person; the variations differ from one another but at the same time have something common to them all: "that treasure, that gold nugget, that hidden diamond," the "self" of a face.

4

I COULD PUT IT DIFFERENTLY: BACON'S PORTRAITS ARE an interrogation on the *limits* of the self. Up to what degree of distortion does an individual still remain himself? To what degree of distortion does a beloved person still remain a beloved person? For how long does a cherished face growing remote through illness, through madness, through hatred, through death still remain recognizable? Where is the border beyond which a self ceases to be a self?

5

FOR A LONG TIME BACON AND BECKETT MADE UP A COUPLE in my imaginary gallery of modern art. Then I read his Archimbaud interview: "I've always been amazed by this comparison between Beckett and myself," Bacon said. Then, farther on: "I've always found that Shakespeare expresses more poetically, more accurately, and in a much more powerful way

what Beckett and Joyce were trying to say." And again: "I wonder if Beckett's ideas about his art didn't end up by killing his creativity. . . . There's something too systematic and too intelligent about him, which is perhaps what's always made me uncomfortable." And finally: "Usually in painting, you always leave too much in that is habit, you never cut enough out, but with Beckett I often get the impression that because he wanted to hone down his text, nothing was left, and in the end his work sounds hollow."

When one artist talks about another, he is always talking (indirectly, in a roundabout way) of himself, and that is what's valuable in his judgment. In talking about Beckett, what is Bacon telling us about himself?

That he doesn't want to be categorized. That he wants to protect his work against clichés.

Also: that he resists the dogmatists of modernism who have erected a barrier between tradition and modern art as if, in the history of art, modern art represented an isolated period with its own incomparable values, with its completely autonomous criteria. Bacon, though, looks to the history of art in its entirety; the twentieth century does not cancel our debts to Shakespeare.

And further: he is refusing to express his ideas on art in too systematic a fashion, lest his art be turned into some sort of simplistic message. He knows that the danger is all the greater because, in our time, art is encrusted with a noisy, opaque logorrhea of theory that prevents a work from coming into direct, media-free, not-pre-interpreted contact with its viewer (its reader, its listener).

Wherever he can Bacon therefore blurs his tracks to throw off the experts who want to reduce his work to a pessimism cliché: he bridles at using the word "horror" with regard to his art; he stresses the role of chance in his painting (chance turning up in the course of the work—an accidental splotch of color that abruptly changes the very subject of the picture); he insists on the word "play" when everyone is making much of the seriousness of his paintings. People want to talk about his despair? Very well, but, he specifies immediately, in his case it is an "exhilarated despair."

6

IN HIS REFLECTIONS ON BECKETT, BACON SAYS: "IN PAINT-ing, we always leave in too much that is habit, we never eliminate enough." Too much that is habit, which is to say: everything in painting that is not the painter's own discovery, his fresh contribution, his originality; everything that is inherited, routine, filler, elaboration as technical necessity. That describes, for example, in the sonata form (of even the greatest—Mozart, Beethoven), all the (often very conventional) transitions from one theme to another. Almost all great modern artists mean to do away with "filler," do away with whatever comes from habit, whatever keeps them from getting directly and exclusively at the essential (the essential: the thing the artist himself, and only he, is able to say).

So it is with Bacon: the backgrounds of his paintings are

supersimple, flat color; *but*: in the foreground, the bodies are treated with a richness of color and form that is all the denser. Now, that (Shakespearean) richness is what matters to him. For without that richness (richness contrasting with the flat-color background), the beauty would be ascetic, as if "on a diet," as if diminished, and for Bacon the issue always and above all is beauty, the explosion of beauty, because even if the word seems nowadays to be hackneyed, out of date, it is what links him to Shakespeare.

And it is why he is irritated by the word "horror" that is persistently applied to his painting. Tolstoy said of Leonid Andreyev and of his tales of terror: "He's trying to frighten me, but I'm not scared." Nowadays too many paintings are trying to frighten us, and instead they bore us. Terror is not an aesthetic sensation, and the horror found in Tolstoy's novels is never there to frighten us; the harrowing scene where doctors operate without anesthetic on the mortally wounded Andrei Bolkonsky is not lacking in beauty; as no scene in Shakespeare lacks it; as no picture by Bacon lacks it.

Butcher shops are horrific, but speaking of them, Bacon does not neglect to remark that "for a painter, there is this great beauty of the color of meat."

7

WHY IS IT THAT, DESPITE ALL BACON'S RESERVATIONS, I continue to see him as akin to Beckett?

Both of them are located at just about the same point in the respective histories of their art, that is, in the very last period of dramatic art, in the very last period of the history of painting. For Bacon is one of the last painters whose language is still oil and brush. And Beckett still wrote for a theater whose basis is the author's text. After him the theater still exists, true, perhaps it is even evolving; but it is no longer the playwrights' texts that inspire, renew, ensure that evolution.

In the history of modern art Bacon and Beckett are not the ones who open the way; they close it down. When Archimbaud asks Bacon which contemporary painters are important to him, he says: "After Picasso, I don't really know. There's an exhibition of pop art at the Royal Academy at the moment. . . . [But] when you see all those pictures collected together, you don't see anything. I find there's nothing in it, it's empty, completely empty." And Warhol? "He isn't important to me." And abstract art? Oh no, he doesn't like it.

"After Picasso, I don't really know." He talks like an orphan. And he is one. He is one even in the very concrete sense of the life he lived: the people who opened the way were surrounded by colleagues, by commentators, by worshippers, by sympathizers, by fellow travelers, by an entire gang. But Bacon is alone. As Beckett is. In the Sylvester interview: "I think it would be more exciting to be one of a number of artists working together. . . . I think it would be terribly nice to have someone to talk to. Today there is absolutely nobody to talk to."

For their modernism, the modernism that closes down the way, no longer matches the modernity around them: a *modernity*

of the fashions propelled by the marketing of art. (Sylvester: "If abstract paintings are no more than pattern-making, how do you explain the fact that there are people like myself who have the same sort of visceral response to them at times as they have to figurative works?" Bacon: "Fashion.") Being modern at the moment when the great modernism is closing down the way is an entirely different thing from being modern in Picasso's time. Bacon is isolated ("there is absolutely nobody to talk to"); isolated from both the past and the future.

8

LIKE BACON, BECKETT HAD NO ILLUSIONS ABOUT THE future of the world or of art. And at that moment in the last days of illusions, both men show the same immensely interesting and significant reaction: wars, revolutions and their setbacks, massacres, the democratic imposture, all these subjects are absent from their works. In his *Rhinoceros*, Ionesco is still interested in the great political questions. Nothing like that in Beckett. Picasso paints *Massacre in Korea*. An inconceivable subject for Bacon. Living through the end of a civilization (as Beckett and Bacon were or thought they were), the ultimate brutal confrontation is not with a society, with a state, with a politics, but with the physiological materiality of man. That is why even the great subject of the Crucifixion, which in past times concentrated within itself the whole ethics, the whole religion, indeed the whole history of the West, becomes in

Bacon's hands a mere physiological scandal. "I've always been very moved by pictures about slaughterhouses and meat, and to me they belong very much to the whole thing of the crucifixion. There've been extraordinary photographs of animals just being taken up before they were slaughtered. And the smell of death . . . "

To link Jesus nailed to the cross with slaughterhouses and an animal's fear might seem sacrilegious. But Bacon is a nonbeliever, and the notion of sacrilege has no place in his way of thinking; according to him, "Man now realizes that he is an accident, that he is a completely futile being, that he has to play out the game without reason." Seen from that angle, Jesus is that accident who, without reason, played out the game. The cross: the final point of the game played out to the end without reason.

No, not sacrilege; rather a clearsighted, sorrowing, thoughtful gaze trying to penetrate to the essential. And what essential thing is revealed when all the social dreams have evaporated and man sees "religious possibilities . . . completely cancelled out for him"? The body. Only *ecce homo*, visible, touching, concrete. For "Certainly we are meat, we are potential carcasses. If I go into a butcher's shop I always think it's surprising that I wasn't there instead of the animal."

This is neither pessimism nor despair, it is only obvious fact, but an obviousness that is veiled by our membership in a collectivity that blinds us with its dreams, its excitements, its projects, its illusions, its struggles, its causes, its religions, its ideologies, its passions. And then one day the veil falls away and we are

left stranded with the body, at the mercy of the body, like the young woman in Prague who, after the shock of an interrogation, went off to the toilet every three minutes. She was reduced to her fear, to the fury of her bowels, and to the sound of the water she heard refilling the toilet tank as I hear it when I look at Bacon's *Figure at a Washbasin* from 1976, or the *Triptych May–June* of 1973. For that young Prague woman it was no longer the police that she had to face up to but her own belly, and if someone was presiding invisibly over that little horror scene, it was no policeman, or apparatchik, or executioner, it was a God— or an Anti-God, the cruel God of the Gnostics, a Demiurge, a Creator, the one who has us trapped forever by that "accident" of the body he cobbled together in his workshop and of which, for a while, we are forced to become the soul.

Bacon often spied on that workshop of the Creator; it can be seen, for instance, in the pictures called *Studies of the Human Body*, in which he unmasks the body as a mere "accident," an accident that could as easily have been put together some other way—for instance, I don't know—with three hands, or with the eyes set in the knees. These are the only pictures of his that fill me with horror. But is "horror" the right word? No. For the sensation these pictures provoke, there is no right word. What they provoke is not the horror we know, the one we feel in response to the insanities of history, to torture, persecution, war, massacres, suffering. No. In Bacon it is a whole different horror: it comes from the *accidental nature*, suddenly unveiled by the painter, of the human body.

14

9

WHAT IS LEFT TO US WHEN WE HAVE COME DOWN TO THAT?

The face;

the face that harbors "that treasure, that nugget of gold, that hidden diamond" that is the infinitely fragile self shivering in a body;

the face I gaze upon to seek in it a reason for living the "senseless accident" that is life.

(1995)

II.

Novels,
Existential Soundings

The Comical Absence of the Comical
(Dostoyevsky: The Idiot)

THE DICTIONARY DEFINES LAUGHTER AS A REACTION "provoked by something amusing or comical." But is that so? We could draw up a whole anthology of different kinds of laughter from Dostoyevsky's *Idiot*. A curious thing: the characters who laugh most in the book are not the ones with the greatest sense of humor; on the contrary, they are those who have none at all. A group of young people leave a country house to stroll in the park; three girls among them "keep laughing so complaisantly at Evgeny Pavlovitch's banter that he comes to suspect they may no longer even be listening to what he's saying." This suspicion "made him burst into sudden laughter." A fine observation: first the collective laughter from the girls who, as they laugh, lose track of their reason for laughing and go on laughing for no reason at all; and then the laughter (this sort quite rare, quite precious) of Evgeny Pavlovitch as he realizes that the girls' laughter is devoid of any comical rationale at all, and, in the face of this *comical absence of the comical*, he bursts into laughter himself.

Walking in that same park, Aglaia shows Mishkin a green bench and tells him that is where she always comes to sit at about seven in the morning, when everyone else is still asleep. That evening there is a birthday party for Mishkin; the gathering

is dramatic and taxing; it ends late in the night, and instead of going off to sleep, an agitated Mishkin leaves the house to wander in the park; he comes across the green bench Aglaia had pointed out for their morning meeting; he sits down on it and lets out "an abrupt, noisy burst of laughter"; clearly this laughter is not "provoked by something amusing or comical"; in fact the next sentence confirms as much: "His anguish did not lessen." He goes on sitting there and dozes off. Then "fresh bright laughter" wakes him. "Aglaia stood before him laughing hard. . . . She was laughing and indignant at the same time." This was not laughter "provoked by something amusing or comical" either: Aglaia is indignant that Mishkin should have the bad taste to fall asleep waiting for her; she laughs to wake him; to let him know he is ridiculous; to rebuke him by *severe laughter.*

Another laugh with no comical cause comes to mind; I remember when I was studying at the Prague film school, standing about in a crowd of other students chatting and laughing; among them is Alois D., a young fellow obsessed with poetry, a nice boy, a bit too self-conscious and oddly stilted. He opens his mouth wide, emits a very loud sound, and gesticulates: that is to say, he is laughing. But he's not laughing like the rest of them: his laughter feels like a copy among originals. If I have never forgotten this tiny episode it is because it was a brand-new experience for me: I was seeing a person laugh who had no sense of the comical and was laughing only to keep from standing out from the crowd, like a spy who puts on the uniform of a foreign army to avoid recognition.

It may be thanks to Alois D. that a passage from Lautréamont's *Les Chants de Maldoror* affected me so strongly at that same period: Maldoror is astounded one day at the sight of people laughing. Not understanding the meaning of that bizarre grimace, and wanting to be like everyone else, he takes up a knife and slices the corners of his mouth.

I sit before the television screen; the show I'm watching is very noisy, there are hosts, actors, stars, writers, singers, models, parliamentarians, government ministers, ministers' wives; and all of them react to any and every remark by opening their mouths wide, emitting very loud sounds, and gesticulating; that is to say they are laughing. And I imagine Evgeny Pavlovitch suddenly landing among them and seeing that laughter, devoid of all comical cause; at first he is horrified, then gradually his terror dissipates, and finally that *comical absence of the comical* "makes him burst into sudden laughter" himself. Whereupon the laughers who a few moments earlier had been looking at him with mistrust are reassured, and they welcome him noisily into their world of humorless laughter, where we are condemned to live.

Death and the Fuss
(Louis-Ferdinand Céline: From Castle to Castle)

IN CÉLINE'S NOVEL *FROM CASTLE TO CASTLE*, A STORY OF a dog; she comes from the icy north of Denmark, where she would disappear for long escapades in the forests. When she arrives in France with Céline, her roaming days are over. Then one day, cancer:

"I tried to lay her down on the straw . . . just after dawn . . . she didn't like me putting her there . . . she didn't want it . . . she wanted to be in some other place . . . over by the coldest part of the house on the pebbles. . . . She stretched out nicely there . . . she began to rattle . . . it was the end . . . they'd told me, I didn't believe it . . . but it was true, she was facing toward what she remembered, the place she'd come from, the North, Denmark, her muzzle toward the north, pointed north, . . . this very faithful dog, in a way . . . faithful to the forests where she used to run off, Korsør, way up there . . . and faithful to her harsh life there, . . . these Meudon woods here meant nothing to her . . . she died with two, three small rattles . . . oh, very discreet . . . no complaints . . . and in this really beautiful position, like in mid-leap—in flight . . . but on her side, helpless, finished . . . nose toward her getaway forests, up there where she came from, where she'd suffered . . . God knows!

"Oh, I've seen plenty of death throes, here . . . there . . . everywhere . . . but by far nothing so beautiful, discreet . . . faithful . . . the trouble with men's death throes is all the fuss . . . somehow man is always on stage . . . even the plainest men."

"The trouble with men's death throes is all the fuss." What a line! And: "somehow man is always on stage." Don't we all recall the ghoulish drama of those famous "last words" on the deathbed? That's how it is: even in the throes of death, man is always on stage. And even "the plainest" of them, the least exhibitionist, because it's not always the man himself who climbs on stage. If he doesn't do it, someone will put him there. That is his fate as a man.

And that "fuss"! Death always treated as something heroic, as the finale of a play, the conclusion of a battle. I read in a newspaper: in some city thousands of red balloons are sent up in homage to people suffering or dead from AIDS. I ponder that "in homage." "In memory," fine; "in remembrance," as a gesture of sorrow and of compassion, yes, that I would understand. But *in homage*? Is there anything to celebrate, to admire, in sickness? Is sickness a personal virtue? But that's the way things are, and Céline knew it: "The trouble with men's death throes is all the fuss . . ."

Many great writers of Céline's generation had, like him, known death, war, terror, torture, banishment. But they went through these terrible experiences on the other side of the wall from him; on the side of the just, of the future victors, or of victims haloed with injustices suffered—in short, on the glory

side. The "fuss," that preening self-satisfaction, was so naturally part of all their behavior that they could no longer see it, or judge it. But Céline, tried for collaboration with the Nazis, lived for twenty years among the condemned and the scorned, in history's trash heap, guilty among the guilty. Everyone around him was reduced to silence; he alone gave voice to that extraordinary experience: *the experience of a life utterly devoid of fuss.*

That experience allowed him to see vanity not as a vice but as a quality inherent in man, a quality that never leaves him, not even in his death throes; and against the background of that irremovable human fuss, the experience allowed him to see the sublime beauty in a dog's death.

Love in Accelerating History
(Philip Roth: The Professor of Desire*)*

How long was it since Karenin and Anna had stopped making love? What about Vronsky? Was he good at bringing her to climax? And Anna? Was she possibly frigid? Did they make love in the dark, in the light, in bed, on the carpet, for three minutes, for three hours, with romantic talk or obscenities, in silence? We don't know a thing about it. In the novels of that time, love stretched over the vast terrain from first encounter to the brink of coitus; that brink was a frontier not to be crossed.

In the twentieth century the novel discovered sexuality, gradually and in all its dimensions. In America the novel heralded and then accompanied the great upheaval in moral custom that was to proceed at dizzying speed: in the 1950s people were still stifling in an unyielding puritanism, and then over a single decade everything changed: that long span from early romance to the act of love vanished. A person was no longer shielded from sex by the no-man's-land of sentiment; now he came into direct, implacable confrontation with it.

In D. H. Lawrence sexual freedom has the feel of a dramatic or tragic revolt. A short time later, in Henry Miller, it is surrounded by lyrical euphoria. Thirty years later, in Philip

Roth, it is simply a given, taken for granted, achieved, collective, commonplace, inevitable, codified: neither dramatic, nor tragic, nor lyrical.

Now we are approaching the limit. There is no "farther." Now it is not laws, or parents, or conventions that oppose desire; everything is permitted, and the only enemy is our own body, denuded, disenchanted, dismasked. Philip Roth is a great historian of American eroticism. He is also the poet of that strange solitude of man left alone to face his body.

However, over these last decades, history has moved so fast that the characters in *The Professor of Desire* cannot help but retain some memory of an earlier time, the time of their parents, who lived their loves more like Tolstoy's characters than Roth's. The nostalgia that suffuses the atmosphere when Kepesh's father and mother appear on the scene is not only the parents' own nostalgia, it is nostalgia for love as such, for the love between father and mother, for that moving, old-fashioned love that seems gone from the world today. (Without the memory of how it used to be, what would remain of love, of the very notion of love?) That strange nostalgia (strange in that it is not bound up with particular characters but set farther off, beyond their own lives, in the background) lends this (seemingly cynical) novel a touching tenderness.

The acceleration of history has profoundly transformed individual lives that, in centuries past, used to proceed from birth to death within a single historical period; today a life straddles two such periods, sometimes more. Whereas history used to advance far more slowly than human life, nowadays it is his-

tory that moves fast, it tears ahead, it slips from a man's grasp, and the continuity, the identity, of a life is in danger of cracking apart. So the novelist feels the need to keep within reach, alongside our own way of life, the memory of the bashful and half forgotten one our predecessors lived.

This is the meaning of the intellectualism of Roth's heroes, all of them professors of literature or writers, constantly meditating on Chekhov or Henry James or Kafka. This is no pointless intellectual display of a self-absorbed literature. It is the yearning to keep past times on the novel's horizon, and not leave the characters in a void where the ancestors' voices would cease to be audible.

The Secret of the Ages of Life
(Gudbergur Bergsson: The Swan*)*

A LITTLE GIRL WAS STEALING SANDWICHES FROM REYKJAVÍK supermarkets. For punishment her parents send her to spend several months in the countryside with a farmer she does not know. In the old Icelandic sagas of the thirteenth century, dangerous criminals used to be sent like this into the interior and, given the immensity of that frozen wilderness, this was tantamount to the death penalty. Iceland: three hundred thousand inhabitants spread over a hundred thousand square kilometers. To withstand the solitude (this is an image from the book), farmers train their binoculars on the far distance to watch other farmers who are also holding binoculars. Iceland: solitudes spying on each other.

The Swan, a picaresque novel about childhood, breathes the Icelandic landscape from every line. But please: do not read it as an "Icelandic novel," as an exotic oddity. Gudbergur Bergsson is a great European novelist. His art is primarily inspired not by some sociological or historical, still less a geographical, curiosity, but by an existential quest, a real *existential insistence*, which places his book at the very center of what could (in my view) be termed the modernity of the novel.

The focus of that quest is the very young heroine ("the little girl," as the author calls her) or, more precisely, the focus is her

age: she is nine years old. Increasingly I think (a truth so obvi-
ous and yet it constantly eludes us) that man exists only in his
specific, concrete age, and everything changes with age. To un-
derstand another person means to understand his current age.
The enigma of age—one of those themes only a novel can il-
luminate. Nine years old: the border between childhood and
adolescence. I have never seen that borderland brought to light
as it is in this book.

What does it mean to be nine years old? It means walking
about in the mists of reveries. But not lyrical reveries. No ideal-
ization of childhood in this book! Dreaming, fantasizing, this
is the little girl's way of taking on a world that is unknown and
unknowable, a world far from friendly. The first day on the
farm, facing an alien and seemingly hostile world, to defend
herself she imagines that "her head spurts an invisible poison
that she sprays over the whole house. That she is poisoning the
rooms, the people, the animals and the air."

The real world she can grasp only through fanciful inter-
pretation. There's the farmer's daughter; behind her neurotic
behavior we make out a love story; but the little girl—what can
she possibly make of it? There is a peasant feast; couples scat-
ter into the landscape; the little girl sees men covering women
with their bodies; she thinks they must be trying to shelter the
women from a downpour: the sky is black with clouds.

The adults are absorbed by practical concerns that take pre-
cedence over any metaphysical questions. But the little girl is
distant from the practical world, so there is no screen between
her and questions of life and death: she is at the metaphysical

age. Leaning over a bog, she studies her image in the water's blue surface. "She imagines her body dissolving and disappearing in the blue. Shall I take the plunge? she asks herself. She lifts a foot and she sees the reflection of her shoe's worn sole." Death intrigues her. A calf is about to be slaughtered. All the neighborhood children are eager to watch it die. Moments before the kill the little girl whispers into the calf's ear: "You know you don't have much time left?" The other children are amused by her line, and one by one they go whisper it to the calf as well. Then its throat is slit and a few hours later everyone is called to the table. The children delight in chewing up the body they saw put to death. Afterward they run over to the cow, the calf's mother. The little girl wonders: does she know that at this very moment we're digesting her child in our stomachs? And she goes to breathe open-mouthed at the cow's nose.

The interval between childhood and adolescence: no longer in need of constant parental care, the little girl suddenly discovers her independence; but because she is still at some distance from the world of the practical, she feels useless; she feels it all the more here alone among people who are not her kin. And yet, even useless, she is captivating to other people. One unforgettable little scene: the farmer's daughter, in her romantic crisis, leaves the house every night (the white Iceland nights) and goes to sit by the river. The little girl, on the watch for her, leaves the house as well, and sits on the ground far behind her. Each is aware of the other's presence, but they do not speak. Then, at a certain moment, the farmer's daughter silently raises a hand and beckons the child to come closer. And every time, refusing

to yield, the child goes back to the farmhouse. A modest scene, but magical. I keep seeing that raised hand, the signal between two beings held apart by their age, incomprehensible to each other, with nothing to communicate but the message: "I am far from you, I have nothing to say to you, but I am here, and I know you are here." That raised hand is the gesture of this book that examines a faraway time, one we can neither relive nor restore, and which for each of us has become a mystery that only the novelist-poet's intuition can bring near to us.

The Idyll, the Daughter of Horror
(Marek Bieńczyk: Tworki)

THE WHOLE STORY TAKES PLACE IN POLAND TOWARD THE
end of World War II. The most familiar shred of history is
viewed from an unfamiliar angle: from a large psychiatric
hospital in Warsaw called Tworki. In order to be original at all
costs? Not at all: in those dark times it was the most natural
thing to seek out some corner to escape to. On the one hand
horror, on the other, refuge.

The hospital is run by the Germans (not by Nazi monsters;
don't go looking for clichés in this book); they employ a few
very young Poles as bookkeepers, among them three or four
Jews with false identity papers. What is instantly striking: these
young people bear no resemblance to the youth of our days;
they are modest, shy, awkward, with a naive thirst for morality
and for goodness; they live their "virginal loves," whose jealou-
sies and disappointments never turn into hatred, in that strange
atmosphere of obstinate gentleness.

Is it because of the half century between them that the
youngsters back then differ so from those of our time? I see
another reason for that dissimilarity: the idyll they were living
was the daughter of horror—of horror hidden but ever present,
always ready to pounce. This is the *Luciferian paradox*: if a

society (ours, for instance) unleashes gratuitous violence and wickedness, it's because it has no real experience of evil, of evil's rule. For the crueler history is, the lovelier the world of refuge appears; the more ordinary a situation, the more it feels like a buoy for "escapees" to cling to.

There are pages in this novel where words recur as refrains, and where the narration becomes a song that lifts us up and away. Where does that music, that poetry, spring from? From the prose of life; from the most ordinary, the most banal of banalities: Jurek is in love with Sonia: his nights of love are mentioned only very briefly, but the movement of the swing Sonia sits upon is described in detail. "Why are you so fond of the swing?" Jurek asks. "Because . . . It's hard to say. I'm here, and then suddenly I'm there, higher up. And here again. And there again." Jurek hears that disarming confession and, marveling, he looks up high, to where "the light brown soles of her shoes became dark. . . . Coming down, . . . her brown soles passed under Jurek's nose. . . ." He looks on, still marveling, and he will never forget.

Near the end of the book Sonia will go off. In the past she had escaped here to Tworki, to live out, in terror, her fragile idyll. She is a Jew; no one knows this (not even the reader). However, she goes to the German director of the hospital and tells him, thus incriminating herself. The director cries, "You're mad! You're mad!" and tries to put her into isolation to save her. But she persists. When we next see her she is no longer alive: "There, high above the juniper brushes on a thick bough

on a thin poplar, high above the ground, Sonia hung, Sonia swung, Sonia was hanged."

On the one hand, the idyll of ordinary life, the idyll recovered, given new value, transformed into song; on the other, the hanged girl.

The Debacle of Memories
(Juan Goytisolo: The Curtain Falls*)*

A MAN, ALREADY ELDERLY, WHO HAS JUST LOST HIS WIFE.
Not much information on his nature or on his biography. No
story. The sole subject of the book is the new stage of life he
has begun: when his wife was at his side, she was also *in front*
of him, marking out the horizon of his life. Now the horizon is
empty: the view has changed.

In the first chapter the man thinks about the dead woman
all night long, disconcerted by the fact that memory fills his
head with old rhymes, bits of pro-Franco songs from his Span-
ish adolescence, before he knew her. Why, why? Are memories
always in such poor taste? Or are they mocking him? He
strains to call up landscapes where he'd been together with her;
he manages to see the scenes but "even fleetingly, she never re-
appeared in them."

When he looks back, his life "lacked coherence: he could
only find fragments, isolated elements, an incoherent succession
of images. . . . The desire to provide a post-facto justification
for the few scattered events would require some falsifying that
might fool other people, but not himself." (And I think: Isn't
that exactly the definition of *biography?* An artificial logic im-
posed on an "incoherent succession of images"?)

From his new perspective the past appears in all its unreality;

and what about the future? Of course, obviously, there's nothing real about the future (he thinks of his father, who'd built a house for his sons that they never lived in). Thus, arm in arm, past and future draw away from him; he walks through a village holding a child's hand, and to his amazement "he feels light, joyful, as free of a past as this child leading him. . . . Everything converges toward the present and is completed in the present." And suddenly, in this existence reduced to the spareness of the present, he finds a happiness he never knew or expected.

After these explorations of time, we can understand God's remark to him: "Even though you were engendered by a drop of sperm, and I was manufactured out of speculation and doctrinal Councils, still the two of us share something: non-existence." God says that? Yes, that being the old man invented in order to, and with whom to, hold long conversations. It is a God who does not exist and who, because he doesn't exist, is free to utter glorious blasphemies.

In one of his conversations this impious God reminds the old man of his visit to Chechnya: it was at the time, after Communism fell, when Russia went to war with the Chechens. For that reason the old man had taken along a copy of Tolstoy's *Hadji Murat*, a novel about the war of those same Russians against those same Chechens some 150 years earlier.

Curiously, like Goytisolo's old man, I too reread *Hadji Murat* at that time. I remember a circumstance that stupefied me then: even though everyone, the salons, the media, had been working themselves up for years over the carnage in Chechnya, I had never heard anybody—not a journalist, not a politician, not an

intellectual—mention Tolstoy, refer to his book. They were all shocked at the scandal of the massacre, but no one was shocked that the massacre was a repetition! And yet that repetition is the true scandal, the queen of all scandals. Only Goytisolo's blaspheming God knows this: "Tell me: what has ever changed on this Earth that legend says I created in a week? What's the good of pointlessly prolonging this farce? Why do people go stubbornly on reproducing?"

Because the scandal of repetition is forever charitably wiped away by the scandal of forgetting (forgetting: that "great bottomless hole where memory drowns," the memory of a beloved woman as well as the memory of a great novel or of a slaughter).

The Novel and Procreation
(Gabriel García Márquez: One Hundred Years of Solitude)

I WAS REREADING *ONE HUNDRED YEARS OF SOLITUDE* WHEN a strange idea occurred to me: most protagonists of great novels do not have children. Scarcely 1 percent of the world's population are childless, but at least 50 percent of the great literary characters exit the book without having reproduced. Neither Pantagruel, nor Panurge, nor Quixote have any progeny. Not Valmont, not the Marquise de Merteuil, nor the virtuous Presidente in *Dangerous Liaisons*. Not Tom Jones, Fielding's most famous hero. Not Werther. All Stendhal's protagonists are childless, as are many of Balzac's; and Dostoyevsky's; and in the century just past, Marcel, the narrator of *In Search of Lost Time*, and of course all of Musil's major characters: Ulrich, his sister Agathe, Walter, his wife, Clarisse, and Diotima; and Schweik; and Kafka's protagonists, except for the very young Karl Rossmann, who did impregnate a maidservant, but that is the very reason—to erase the infant from his life—that he flees to America and the novel can be born. This infertility is not due to a conscious purpose of the novelists; it is the spirit of the art of the novel (or its subconscious) that spurns procreation.

The novel was born with the Modern Era, which made man, to quote Heidegger, the "only real subject," the ground for everything. It is largely through the novel that man as an

individual was established on the European scene. Away from the novel, in our real lives, we know very little about our parents as they were before our birth; we have only fragmentary knowledge of the people close to us: we see them come and go, and scarcely have they vanished than their place is taken over by others; they form a long line of replaceable beings. Only the novel separates out an individual, trains a light on his biography, his ideas, his feelings, makes him irreplaceable: makes him the center of everything.

Don Quixote dies and the novel is over; that ending is so perfectly definitive only because Don Quixote has no children; with children, his life would be prolonged, imitated or contested, defended or betrayed; a father's death leaves the door open; in fact so we are told ever since our own childhood: your life will continue in your children, children are your immortality. But if my story can go on beyond my own life, that means that my life is not an independent entity; it means it is unfinished, unfulfilled; it means there is something utterly concrete and earthly into which the individual blends, agrees to blend, consents to be lost in: family, posterity, tribe, nation. It means that the individual person, as "ground for everything," is an illusion, a gamble, the dream of a few European centuries.

With García Márquez's *One Hundred Years of Solitude*, the art of the novel seems to emerge from that dream; the center of attention is no longer an individual but a procession of individuals; they are each original, inimitable, and yet each of them is merely the brief flash of a sunbeam on the swell of a river; each of them carries with him his future forgotten self, and each is

conscious of that, none of them remains on the novel's stage from beginning to end; the mother of the whole tribe, Old Ursula, is 120 when she dies, and that's a long time before the book ends; and all the characters have similar names—Arcadio José Buendía, José Arcadio, José Arcadio the Second, Aureliano Buendía, Aureliano the Second—such that the edges between them blur and the reader confuses them. To all appearances the era of European individualism is no longer their era. But then what is their era? An era that goes back to America's Indian past? Or some future era when the human individual will blend into the human anthill? I sense that this novel, which is an apotheosis of the art of the novel, is at the same time a farewell to the age of the novel.

III.

Blacklists, or Divertimento in Homage to Anatole France

1

LONG AGO A FRENCH FRIEND OF MINE CAME TO VISIT Prague with a few of his countrymen, and I found myself in a taxi with a woman whom, to keep up the conversation, I (inanely) asked which French composer she liked best. Her response was immediate, spontaneous, and vehement, and it has stuck in my head: "Absolutely not Saint-Saëns!"

I failed to ask her: "And what have you heard by him?" She would certainly have answered, still more indignantly: "By Saint-Saëns? Absolutely nothing. Not a thing!" For the issue was not about her aversion to some particular music, it was about something more serious: about having nothing to do with a name on the blacklist.

2

BLACKLISTS. THEY WERE ALREADY A GREAT PASSION OF THE avant-garde before World War I. When I was about thirty-five, I was translating Apollinaire into Czech, and I happened across his little 1913 manifesto, in which he was awarding "turds" and "roses." It was turds for Dante, Shakespeare, and Tolstoy, but also for Poe, Whitman, Baudelaire! The roses went to himself, Picasso, and Stravinsky. This manifesto was charming and

funny (Apollinaire awarding a rose to Apollinaire!), and I was delighted by it.

3

TEN YEARS LATER, AS A NEW ÉMIGRÉ IN FRANCE, I WAS chatting with a young man when out of the blue he asked me: "Do you like Barthes?" At that point I was no longer naive; I knew I was being tested. And I also knew that at just that moment Roland Barthes topped every gold list. "Of course I like him. And how! You mean Karl Barth, right? The inventor of negative theology! A genius! Kafka's work is inconceivable without him!" My examiner had never heard the name Karl Barth, but since I had linked him to Kafka, untouchable of untouchables, he had nothing more to say. The discussion slid away to other subjects. And I was pleased with my answer.

4

AROUND THAT SAME TIME, AT A DINNER PARTY, I HAD to pass another test. A music lover asked to know my favorite French composer. Ah, see how situations keep repeating! I could have answered, "Absolutely not Saint-Saëns!" but I chose to let a memory seduce me: In the 1920s my father had brought home from Paris the scores for Darius Milhaud's piano works, and had played them in Czechoslovakia to the sparse (very sparse)

audience for concerts of modern music. Moved by the memory, I declared my love for Milhaud and for the whole group of "The Six." I was all the more effusive in my praise because I meant it to express my love for the country where I was just beginning my second life. My new friends heard me out sympathetically. And sympathetically they gave me to understand that those people I considered modern had not been so for a long time, and that I ought to seek out other names to praise.

And indeed, that happens continually, those shifts from one list to another, and innocent souls are caught in the snare. In 1913 Apollinaire had awarded Stravinsky a rose, never knowing that in 1946 Theodor Adorno would give the rose to Schoenberg and to Stravinsky he would solemnly award a turd.

And Cioran! In the time since I came to know him, he's done nothing but trail from one list to the other, in the dusk of his life ending up on the black one. And in fact he was the one who, not long after my arrival in France, when I mentioned Anatole France in his presence, leaned close to my ear and whispered with a sardonic little laugh, "Never mention his name aloud here, everyone will laugh at you!"

5

THE FUNERAL CORTEGE THAT FOLLOWED ANATOLE FRANCE to his grave was several kilometers long. Then everything changed. Aroused by his death, four young Surrealist poets wrote a pamphlet against him. With his chair at the Académie

Française vacated, another poet, Paul Valéry, was elected to take his place. By tradition the successor gives a eulogy for the departed. Throughout his whole panegyric, which became legendary, Valéry managed to talk about M. France without ever saying his name, and to celebrate that anonymous figure with conspicuous reserve.

And indeed, no sooner had France's coffin hit the floor of the trench than his march toward the blacklist began. How is that possible? Could the sneers of a few poets with a limited following themselves have the power to influence a public a hundred times more numerous? Where did it disappear to, what happened to the admiration of those thousands of people who had walked behind his coffin? Where do the blacklists draw their power from? What is the source of the secret commandments they obey?

The fashionable drawing rooms. Nowhere in the world have salons played so great a role as in France. Thanks to the centuries-old aristocratic tradition, and then thanks to Paris, where, in a small area, the whole intellectual elite of the nation piles together and manufactures opinions; it propagates them not through critical studies or expert discussion but through dazzling phrasemaking, wordplay, glittering nastiness (that's the way it is: decentralized countries dilute meanness, centralized ones concentrate it). Again about Cioran: at the time when I was convinced that his name must gleam on every gold list, I ran into a renowned intellectual: "Cioran?" he said, looking me long in the eyes. Then, with a lengthy, suppressed chuckle: "A dandy of nothingness."

6

WHEN I WAS NINETEEN, A FRIEND SOME FIVE YEARS OLDER than I, a convinced Communist (like me), a member of the Resistance during the war (a real *résistant* who had put his life on the line, and whom I admired for that), confided a project to me: he planned to produce a new card game in which the kings, queens, and jacks would be replaced by Stakhanovites, partisans, or Lenins; and why not, why not combine people's ancient love for cards with a political education?

Then one day I read a Czech translation of Anatole France's novel *The Gods Are Thirsty*, set in the time of the French Revolution. The protagonist, Gamelin, a young painter and a supporter of the Jacobin faction, has invented a new card game that replaces the king, queen, and jack in each suit with Liberty, Equality, Fraternity. . . . I was stunned. So then is history nothing but a long string of variations? For I was sure that my friend had never read a single line of Anatole France. (No, never; I asked him explicitly.)

7

WHEN I WAS A YOUNG MAN, TRYING TO FIND MY WAY in a world sliding toward the abyss of a dictatorship whose reality no one had foreseen, desired, imagined, especially not the people who had desired and celebrated its arrival, the only

book that managed to tell me anything lucid about that un-
known world was *The Gods Are Thirsty*.

Gamelin, the painter with the new playing cards, may be the
first literary portrait of a "politically engaged artist." In the early
days of Communism, what a lot of such people I saw around me!
Still, what captivated me in France's novel was not its *condem-
nation* of Gamelin but the *mystery* of Gamelin. I say "mystery"
because that man who ended up sending dozens of people to
the guillotine would probably in some other time have been a
kindly neighbor, a good colleague, a gifted artist. How can an
unarguably decent man harbor a monster inside him? Would the
monster be lurking in him in peaceful political times as well? un-
detectable? or perhaps actually discernible? Those of us who have
known *terrifying* Gamelins—are we capable of spotting the mon-
sters sleeping inside the *kindly* Gamelins that surround us today?

In my native country, as people were shedding their ideologi-
cal illusions, the "Gamelin mystery" ceased to interest them. A
bastard is a bastard, what's the mystery? The existential enigma
has disappeared behind political certitude, and certitudes don't
give a damn about enigmas. This is why, despite the wealth of
their lived experiences, people emerge from a historic ordeal
still just as stupid as they were when they went into it.

8

IN THE GARRET JUST ABOVE GAMELIN'S APARTMENT,
there is a shabby little room inhabited by Brotteaux, a onetime

banker recently expropriated; Gamelin and Brotteaux: the novel's two poles. In their strange antagonism it's not virtue opposed to crime nor counterrevolution versus revolution: Brotteaux is not fighting any battle at all; he has no ambition to impose his own thinking on the dominant mind-set, he is only claiming his right to think unacceptable thoughts and to doubt not only the revolution but man as God has created him. At a time when my own ideas were taking shape, this Brotteaux fascinated me; not for this or that particular idea of his, but for his attitude: of *a man who refuses to believe.*

Thinking back later on Brotteaux, I realized that in the Communist period there were two basic forms of disagreement with the regime: one based on a belief and the other on skepticism; one moralistic and the other immoralist; one puritanical and the other libertine; the one reproaching Communism for not believing in Jesus, the other accusing it of turning into a new Church; the one angry that it permitted abortion, the other accusing it of making abortion difficult. (Obsessed with their common enemy, these two positions scarcely perceived their divergence, and it rose up all the more powerfully when Communism collapsed.)

9

AND WHAT ABOUT MY FRIEND AND HIS CARDS? HE NEVER managed to sell his idea, any more than Gamelin did. But I don't believe that depressed him. Because he had a sense of

humor. When he first told me about his project, I remember, he was laughing. He recognized that his idea was funny, but in his view, why shouldn't a funny idea also be useful to a good cause? Comparing him with Gamelin, I think it was a sense of humor that distinguished one man from the other, and that certainly, because of his humor, my friend could never have become an executioner.

In the novels of Anatole France humor is constantly present (though always subtle); in another book, *La rôtisserie de la reine Pédauque*, one can't help enjoying it, but what's humor doing on the bloody terrain of one of the worst tragedies in history? Yet that is exactly what is unique, fresh, admirable: the skill to resist the nearly obligatory pathos of so somber a subject. For only a sense of humor can discern the humorlessness in others. And discern it *with horror*! Only the lucidity of humor could see in Gamelin's deepest soul his dark secret: *the desert of seriousness*, the *humorless desert*.

10

CHAPTER 10 OF *THE GODS ARE THIRSTY*: HERE IS WHERE the light, merry, happy atmosphere is concentrated; from here a glow spreads over the whole of the novel, without this chapter the book would grow somber and lose all its charm. In the darkest days of the Terror, a few young painters—Gamelin with his friend Desmahis (a likable scamp and skirt chaser), a famous actress (together with some other young women), an

art dealer (with his daughter Élodie, Gamelin's fiancée), and even Brotteaux (incidentally an amateur painter as well)— set out from Paris to spend a couple of pleasant days together. Their adventures over this brief interlude only amount to some ordinary little events, but it is this very ordinariness that exudes happiness. The only erotic episode (Desmahis couples with a servant girl who's wider than she is tall because of her freakish double-boned skeleton) is grotesque but insignificant, and happy anyhow. Gamelin, recently appointed to the Revolutionary Tribunal, is comfortable with the group, as is Brotteaux, his future guillotine victim. The bunch is bound together by a mutual affection, an affection made easy enough by the indifference most Frenchmen already feel for the Revolution and its rhetoric—an indifference that of course they prudently keep masked, so that Gamelin is unaware of it; he is content with the other people though at the same time quite alone among them (alone but not yet aware of it).

11

THE PEOPLE WHO MANAGED TO KEEP ANATOLE FRANCE'S name on the blacklist for a century were not novelists but poets: mainly the Surrealists: Aragon (his great conversion to the novel still lay ahead of him), Breton, Éluard, Soupault (each of them wrote his own text for the joint pamphlet).

As avid young avant-gardists, they were all irritated by France's too-official celebrity; as authentic lyric poets, they fo-

cused their aversion on the same key words: Aragon reproached the dead man for "irony"; Éluard for "skepticism and irony"; Breton for "skepticism, realism, heartlessness." So their vehemence had a certain consistency, a logic, although actually I must say I find that "heartlessness" a little disconcerting coming from Breton: could this great nonconformist mean to spank the cadaver with the strap of such a tired kitsch word?

In *The Gods Are Thirsty*, France himself talks about heart. Gamelin sits among his new colleagues, the Revolutionary judges, who were required to speedily sentence the accused to death or acquit them; France describes them this way: "On the one hand the indifferent, the lukewarm, the hair-splitters, unmoved by any passion, and on the other, those who gave over to feeling, cared little for rational argument and *judged with their hearts. That second group always convicted.*" (The emphases are mine.)

Breton was right: Anatole France did not have enormous respect for the heart.

12

THE SPEECH IN WHICH PAUL VALÉRY ELEGANTLY REPRIMANDED Anatole France was noteworthy for another reason as well: it was the first oration delivered from the dais of the Académie Française that was about a novelist—that is, about a writer whose importance rested almost entirely on his novels. In fact, through the whole nineteenth century, the greatest period

of the French novel, novelists were fairly well ignored by the Académie. Is that not absurd?

Not completely absurd. For the figure of the novelist did not fit the notion of a person who by his ideas, his attitudes, his moral example, could represent a nation. The status of "great man," which the Académie quite naturally required of its members, is not what a novelist aims for; by the nature of his art, he is secretive, ambiguous, ironical (yes, ironical, the Surrealist poets in their pamphlet hit it on the head); and above all: concealed as he is behind his characters, it is difficult to reduce him to some particular conviction or attitude.

So although a few novelists have entered the collective memory as "great men," this is only through the play of historical coincidence, and for their books it is always a calamity.

I think of Thomas Mann laboring to get across the humor in his novels; an effort both touching and futile, for in the period when his country's name was stained by Nazism, he was the only writer who could speak to the world as an heir to the Germany of old, the land of culture; the gravity of his situation hopelessly obscured the seductive smile of his books.

I think of Maxim Gorky; hoping to do something useful to aid the poor and their failed revolution (the one in 1905), he wrote his dullest book, *Mother*, which much later became (by decree of the apparatchiks) the sacred model of so-called socialist literature; behind his person elevated into a statue, his novels (which are far freer and finer than anyone cares to believe) have disappeared.

And I think of Solzhenitzyn. Was that great man a great novelist? How would I know? I have never opened one of his books. His resounding declarations of political position (whose courage I applauded) made me feel I knew in advance whatever he had to say.

13

THE *ILIAD* ENDS LONG BEFORE THE FALL OF TROY, AT THE moment when the war is still undecided and before the famous wooden horse exists even in Ulysses' head. For such was the aesthetic commandment set out by the first great epic poet: thou shalt never let the timing of a character's personal destiny coincide with the timing of historical events. The first great epic poem was set to the timing of personal destinies.

In *The Gods Are Thirsty*, Gamelin is decapitated within days of Robespierre, he perishes at the same moment as the Jacobins' power; the timing of his life directly parallels the rhythm of history. In my secret soul, did I blame Anatole France for violating Homer's commandment? Yes. But later on I thought better of it. For the horror of Gamelin's fate is exactly that: history swallowed up not only his thoughts, his sentiments, his actions, but even the timing of his life; he is a man eaten whole by history; he is just a human filler for history; and the novelist had the audacity to grasp that horror.

So I will not say that the coincidence of history's timing with the timing of the protagonist's life is a *flaw* in the book; but I

won't deny that it is its *handicap*; because the coincidence of these two time frames invites the reader to see *The Gods Are Thirsty* as a "historical novel," an illustration of history. A snare that is unavoidable for a French reader, since, in his country, the Revolution has become a sacred event, transformed into endless national debate, that divides people, sets them against one another, such that any novel that proposes to describe the Revolution is instantly chewed up by this insatiable debate.

This explains why *The Gods Are Thirsty* has always been better understood outside France than within it. For such is the fate of any novel whose action is too tightly bound to a narrow historical period: fellow citizens automatically look for a document of what they themselves experienced or passionately debated; they look to see if the novel's image of history matches their own; they try to work out the author's political stances, impatient to judge them. The surest way to spoil a novel.

For in a novelist the *passion to know* is not aimed at politics or history. What new thing can a novelist possibly uncover about events described and discussed in thousands of learned books of all sorts? There's no doubt that in Anatole France the Terror looks dreadful, but take a good look at the last chapter, which unfolds as full-blown counterrevolutionary euphoria! The handsome dragoon Henri, the fellow who used to denounce people to the Revolutionary Tribunal, shines again among the victors! The stupid fanatical young royalists burn a mannequin of Robespierre and hang a Marat effigy from a lamppost! No, the novelist wrote his book not to condemn the Revolution but to examine the mystery of the actors in it, and other mysteries

as well: the mystery of the comical infiltrating the horrors, the mystery of the boredom that accompanies dramas, the mystery of the heart that finds delight in the sight of heads rolling, the mystery of humor as the last refuge of the human. . . .

14

PAUL VALÉRY, AS EVERYONE KNOWS, DIDN'T THINK MUCH of the art of the novel; this is apparent in that oration to the Académie; he is interested only in Anatole France's intellectual views, not his novels. In this he has never lacked for zealous disciples. I open my copy of *The Gods Are Thirsty*: at the back a bibliography recommends five books about the author: *Anatole France, Polemicist; Anatole France, a Passionate Skeptic; The Adventures of Skepticism (an Essay on the Intellectual Evolution of Anatole France); Anatole France, in His Own Words; Anatole France, the Formative Years.* The titles provide a good indication of where the attraction lies: (1) in France's biography, and (2) in his views on the intellectual conflicts of his time. But why is no one ever interested in the essential? In his work did Anatole France say something about human life that had never been said before? Did he bring something new to the art of the novel? And if so, how would we describe, and define, his poetics of the novel?

In a single quick sentence Valéry compares France's books with those of Tolstoy, Ibsen, Zola, and rates them "light works." Sometimes, unconsciously, meanness can become praise! For

the admirable element in France's work is, actually, that very lightness of style with which he dealt with the weight of the Terror! A lightness unequaled in any other of the great novels of his century. In a vague way it sometimes reminds me of works from the preceding century, of *Jacques le Fataliste* or *Candide*. But in Diderot or Voltaire, the lightness of the narration floats above a world whose everyday reality remains unseen and unexpressed; by contrast, in *The Gods* the *banality of the everyday*, that great discovery of the nineteenth-century novel, is always present, not in long descriptions but in details, remarks, brief surprising observations. This novel is a *cohabitation of unbearably dramatic history with unbearably banal dailiness*, a cohabitation that sparkles with irony, given that these two opposite aspects of life constantly clash, contradict, and mock each other. This cohabitation makes for the book's style and is also one of its major themes (*ordinary life during the massacres*). But enough; I don't want to do an aesthetic analysis myself of Anatole France's novels. . . .

15

I DON'T WANT TO BECAUSE I'M NOT READY. I DO HAVE strong memories of *The Gods Are Thirsty* and *La reine Pédauque* (those books were part of my life), but other novels by France have left only vague memories and some I never read at all. Which is, actually, the way we know novelists, even those we like a lot. I say "I love Joseph Conrad." And my friend says,

"Me, not so much." But are we talking about the same writer? I've read two Conrad novels, he just one, and it's one I don't know. And yet each of us, in all innocence (in all innocent impertinence), is sure he has an accurate idea of Conrad.

Is that the situation in all the arts? Not entirely. If I told you that Matisse was a second-rate painter, it would take you no more than fifteen minutes in a museum to see that I'm a fool. But how could one reread all of Conrad? It would take weeks! The different arts reach our brains in different ways; they lodge there with differing ease, at different speeds, with different degrees of inevitable simplification; and for different durations. We all talk about the history of literature, we claim connection to it, convinced we know it, but what, *concretely*, is the history of literature in the common memory? A patchwork of fragmentary images that, by pure chance, each of thousands of readers has stitched together for himself. Beneath the hole-ridden sky of such a vaporous, illusory memory, we are all at the mercy of blacklists, of their arbitrary, untestable verdicts, and always ready to ape their stupid elegance.

16

I COME ACROSS AN OLD LETTER, DATED AUGUST 20, 1971, and signed "Louis." The rather long letter is Aragon's response to what I had written him (and of which I retain no memory). He tells me what he has been doing over the previous month, about books he is preparing for publication ("The *Matisse* is

coming out around September 10"), and in that context I read: "But that pamphlet on Anatole France is worthless, I don't think I even have a copy of the thing, it just had some insolent piece of mine in it, that's all."

I very much liked the novels Aragon wrote after the war— *Holy Week, The Kill. . . .* When later on he wrote a preface for the French edition of my book *The Joke*, I was delighted by the chance to know him and I tried to stretch out my connection with him. I behaved like that woman in the taxi whom I'd asked, for the sake of conversation, who her favorite French composer was. To show off my familiarity with the Surrealists' pamphlet against Anatole France, I must have asked Aragon some question about it in my letter. These days I can imagine his vague disappointment: "That insolent little piece, is that the only thing that interests this Kundera fellow, out of everything I ever wrote?" And further (far more sorrowfully): "Will there be nothing left of us but worthless stuff?"

17

I'M COMING TO THE END HERE AND, AS A FAREWELL, I again recall chapter 10 of *The Gods*, that lamp lighted in the first third of the novel whose gentle glow goes on brightening it to the last page: a small band of bohemian friends slip out of Paris for a couple of days and set up in a country inn; they're all looking for an adventure, but only one materializes: night falls and Desmahis, the likable scamp and skirt chaser, goes up

to the attic looking for one of the girls of their group; she's not there, but he finds someone else: a servant for the inn, a freakish girl who, because of a double skeleton, is wider than she is tall; she is asleep there, her chemise rumpled at her waist and her legs spread wide. Without a second thought Desmahis makes love to her. This quick coupling, this genial rape, is soberly described in a brief paragraph. And so that nothing ponderous, or ugly, or naturalistic should linger from the episode, the next day as the band prepares to leave, the double-boned girl is up on a ladder in fine spirits, cheerful, bidding everyone good-bye and tossing flowers down on them. And two hundred pages farther on, at the very end of the novel, Desmahis, the genial fucker of the double-boned girl, is lying in the bed of Élodie, the fiancée of his friend Gamelin, who has already been guillotined. And all that without a touch of pathos, or accusation, or snicker— with just a light, light, light veil of sadness.

IV.

THE DREAM OF TOTAL HERITAGE

A Dialogue on Rabelais and the Misomusists

GUY SCARPETTA: I RECALL YOUR WORDS: "I AM ALWAYS surprised by how little influence Rabelais has had on French literature. On Diderot, of course. On Céline. But apart from that?" And you recalled that Gide, in response to a survey in 1913, left Rabelais out of his pantheon of the novel but did include Fromentin. And what about you? What does Rabelais mean to you?

MILAN KUNDERA: *Gargantua-Pantagruel* is a novel from before novels existed. A miraculous moment, never to return, in which an art had not yet come into being as such and therefore was not yet bound by any norms. As soon as the novel begins to assert itself as a special genre or (better) an autonomous art, its original freedom shrinks; aesthetic censors arrive thinking they can decree what does or does not correspond to the description of that art (what is or isn't a novel), and an audience forms and takes on its own habits and demands. Because of that *initial freedom* of the novel, Rabelais' work contains enormous aesthetic possibilities, some of which have been realized in the novel's later evolution and others never have been. Well, a novelist inherits not only everything that has been done but also everything that was possible. Rabelais reminds us of that.

GS: So then, Céline is one of the few French writers, perhaps the only one, to draw explicitly on Rabelais. What do you think of his text?

MK: "Rabelais missed his shot," Céline says. "What he hoped to do was develop a language for everybody, a real one. He wanted to democratize the language . . . bring the spoken language into the written language." Céline felt that the academic style has won out: "No, France can no longer understand Rabelais: the country has gone precious." A kind of preciosity, yes, it's a curse of French literature, of the French mind, I agree. On the other hand, I do have reservations when I read in that same Céline piece: "Here's my essential point: all the rest (imagination, creative power, the comical, and so on), none of that interests me. Language, nothing but language." At the time he wrote that, in 1957, Celine couldn't have known that this *reduction of the aesthetic to the linguistic* was going to become one of the axioms of the future academic foolishness (which he would certainly have detested). In fact, the novel is also: characters; plot; composition; style (a range of styles); the nature of imagination. Consider, for instance, that pyrotechnic play of styles in Rabelais: prose, verse, joke lists, parody science discourse, meditations, allegories, letters, realistic descriptions, dialogues, monologues, pantomimes. . . . Talking about some "democratizing of the language" doesn't begin to explain that profusion of forms: virtuosic, exuberant, playful, euphoric, and highly *artificial* (artificial doesn't mean precious). The formal richness of Rabelais' novel is without equal. This is one of those possibilities forgotten in the later evolution of the novel. It was rediscovered only three centuries later, in James Joyce.

GS: In contrast to that "forgetting" by French novelists, Rabelais is an essential reference for many foreign writers: you've

mentioned Joyce, of course; and we might look at Gadda, but also at some contemporary writers: in my own experience, I've always heard the most fervent talk about Rabelais from Danilo Kiš, Carlos Fuentes, Goytisolo, or you yourself. . . . So things go on as if that source of the novel genre was unrecognized in its own land, and claimed abroad. How do you explain that paradox?

MK: I'd only dare speak to the most superficial aspect of the paradox. The Rabelais that entranced me when I was about eighteen is a Rabelais written in an admirable modern Czech language. Because his antique French is hard to understand these days, for a Frenchman Rabelais will always be more old-fashioned, more archaic, more interesting for a scholar than for a reader who comes to know him through a translation (a good one).

GS: When was Rabelais translated into Czech? By whom? How come? And how has the translation fared?

MK: He was translated by a small collective of excellent romance-language specialists who called themselves "the Bohemian Thélème." The *Gargantua* translation appeared in 1911. The whole set, the five volumes, was published in 1931. On this point: after the Thirty Years' War, Czech as a literary language nearly disappeared. When the nation began to be reborn (like other Central European nations) in the nineteenth century, the challenge was: make Czech a European language equal to the others. Bringing off a translation of Rabelais—what a dazzling proof of a language come to maturity! And in fact, *Gargantua-Pantagruel* is one of the finest books ever written in

Czech. For modern Czech literature Rabelais has been a very important inspiration. The greatest Czech modernist of the novel, Vladislav Vančura (who died in 1942, shot by the Germans), was a passionate Rabelaisian.

GS: And as to Rabelais elsewhere in Central Europe?

MK: His history in Poland was almost the same as in Czechoslovakia: the translation by Tadeusz Boy-Żeleński (also shot by the Germans, in 1941) was magnificent, one of the greatest written texts in Polish. And it was that Polonized Rabelais that enchanted Gombrowicz. When he speaks of his "masters" he cites three in the same breath: Baudelaire, Rimbaud, and Rabelais. Baudelaire and Rimbaud were the usual reference points for all the modernists, but claiming Rabelais as a model, that was rarer. The French Surrealists didn't much care for him. To the west of Central Europe, avant-garde modernism was childishly antitraditional, and it was expressed almost exclusively in lyric poetry. Gombrowicz's modernism is different. It's mainly a modernism of the novel. And besides, Gombrowicz was not interested in a naive challenge to the values of tradition; rather he wanted to "re-value" them, "trans-value" them (in the Nietzschean sense: *Umwertung aller Werte*). Rabelais-Rimbaud as a pair, as a program: now, here was such "transvaluation of values," a new perspective, one with significance for the great figures of modernism as I myself conceive it.

GS: In France's education tradition (the one expressed, for instance, in the literature textbooks), there is a tendency to put Rabelais back into the "spirit of the serious," to make him out simply a humanist thinker, to the detriment of the qualities of

play, exuberance, fantasy, obscenity, laughter that suffuse his work, of that "carnival" element that Bakhtin made much of. What's your feeling about this diminution, or mutilation? Should we see it as a rejection of that element of irony toward all orthodoxies, toward all "positive thinking," that you've said characterizes the very essence of the novel genre?

MK: It's even worse than a rejection of irony, of fantasy, etc. It's an indifference to art, a rejection of art, an allergy to art, what I've earlier called "misomusy" (detestation of the Muses): they're removing Rabelais' work from any aesthetic consideration. Now that historiography and literary theory are becoming ever more "misomusistic," writers are the only people who can say anything interesting about Rabelais. One little recollection: an interviewer asked Salman Rushdie what he loved best in French literature; he replied, "Rabelais and *Bouvard et Pécuchet*." That answer says more than any number of long textbook discussions. Why *Bouvard et Pécuchet*? Because it's a different Flaubert from the one who wrote *L'Éducation sentimentale* and *Madame Bovary*. Because it's the Flaubert of the non-serious. And why Rabelais? Because he's the pioneer, the founding father, the genius of the non-serious in the art of the novel. With those two references Rushdie underscores the principle of the *non-serious* that is precisely one of those possibilities for the art of the novel that lay neglected throughout its history.

(1994)

The Dream of Total Heritage in Beethoven

I KNOW, HAYDN HAD ALREADY, MOZART HAD ALREADY occasionally revived polyphony in their classical works. However, in Beethoven that resurrection seems to me far more persistent and deliberate: I'm thinking of his late piano sonatas; op. 106, the *Hammerklavier*, in which the last movement is a fugue with all the old polyphonic richness but driven by the spirit of the new era: longer, more complex, more sonorous, more dramatic, more expressive.

The op. 110 sonata amazes me even more: the fugue is part of the third (final) movement; it is introduced by a short passage of a few bars marked *recitative* (the melody loses its songlike quality here and becomes speech; intensified, with an irregular rhythm, consisting mainly of the repetition of the same notes in sixteenth and thirty-second notes); then comes a composition in four parts. The first: an *arioso* (entirely homophonic: a melody *una corda*, accompanied by chords in the left hand; mood *classically* serene); the second: a fugue; the third: a variation on that *arioso* (the same melody turns expressive, plaintive; the mood *romantically* torn apart); the fourth: a continuation of that fugue, with the theme inverted (it moves from *piano* to *forte* and in the four last bars becomes entirely homophonic, without a trace of polyphony).

So within its brief ten-minute span, this third movement (including its short *recitative* prologue) is notable for its extraordinary *heterogeneity* of emotion and form; yet the listener does not realize this, because the complexity seems so natural and simple. (Let that be a lesson: the formal innovations of the great masters always have a certain discreetness about them; such is true perfection; only among the small masters does novelty seek to call attention to itself.)

Bringing the fugue (the model form of polyphony) into the sonata (the model form of classical music), Beethoven seems to have laid his hand on the scar left by the passage between two great periods: the one stretching from the earliest polyphony in the twelfth century up to Bach, and the next one grounded in what we have come to term "homophony." As if he had wondered: is the legacy of polyphony still mine? and if it is, how could polyphony, which requires each voice to be thoroughly audible, accommodate the recent development of the orchestra (like the transformation of the modest early piano into the *Hammerklavier*), where rich sonority no longer allows us to distinguish individual voices? and how could the serene spirit of polyphony resist the emotional subjectivity of the music born of classicism? can two such opposite conceptions of music coexist? and coexist in the same work (the op. 106 sonata)? And even more narrowly, within the same movement (the last movement of op. 110)?

I imagine that Beethoven wrote his sonatas dreaming he was heir to the *whole* of European music since its beginnings.

This dream I impute to him, the dream of the great synthesis (a synthesis of two seemingly irreconcilable periods), reached its complete fulfillment only a hundred years later, with the greatest composers of modernism, particularly Schoenberg and Stravinsky, who themselves were also, despite their totally opposite pathways (or which Adorno saw as totally opposite*), not (merely) the perpetuators of their immediate precursors but— and in an entirely conscious way—*total heirs* (and probably the last of them) to *the whole history of music.*

* I discuss the relation between Stravinsky and Schoenberg in detail in part 3 of *Testaments Betrayed*, "Improvisation in Homage to Stravinsky": Stravinsky's entire oeuvre is a great summation of European music in the form of a long journey from the twelfth century to the twentieth. Schoenberg's music, too, embraces the experience of the whole history of music, not in Stravinsky's "horizontal," "epic," rambling fashion, but in the very synthesis of his "twelve-tone system." Adorno presents these two aesthetics as entirely contradictory; he does not see what, from a distance, makes them similar.

The Arch-Novel:
An Open Letter for the Birthday of Carlos Fuentes

MY DEAR CARLOS:

An anniversary for you, and for me too: seventy years since your birth, and thirty since I met you for the first time, in Prague. You came there a few months after the Russian invasion with Julio Cortázar, with Gabriel García Márquez, to show your concern for us Czech writers. A few years later I came to live in France when you were the Mexican ambassador there. We met often and talked. A little about politics, a lot about the novel. Especially on that second subject, we were very close to each other.

We talked about the astonishing kinship between your vast Latin America and my little Central Europe, the two parts of the world similarly marked by the historical memory of the Baroque, which makes a writer hypersensitive to the seductions of the fantastical, magical, oneiric imagination. And another point in common: both our two parts of the world played a decisive role in the evolution of the twentieth-century novel, of the modern—let's say post-Proustian—novel: first, during the 1910s, 1920s, 1930s, thanks to the constellation of great writers from my part of Europe: Kafka, Musil, Broch, Gombrowicz . . . (we were surprised to find we had the same

admiration for Broch, greater, I believe, than what his compatriots felt, and different: in our view, he opened new aesthetic possibilities for the novel; he was thus above all the author of *The Sleepwalkers*); then, through the nineteen-fifties, -sixties, and -seventies, thanks to another great constellation of writers in your part of the world who continued transforming the aesthetic of the novel: Juan Rulfo, Carpentier, Sabato, then you and your friends. . . .

Two fidelities shaped us: fidelity to the revolution of modern art in the twentieth century and fidelity to the novel. Two fidelities not at all convergent. For the avant-garde (the ideologized version of modern art) has always relegated the novel to a position outside modernism, considering the form to be old hat, irrevocably conventional. When, later on, in the 1950s and 1960s, the latter-day avant-gardes began to create and proclaim their own modernism for the novel, they did it in a purely negative way: a novel with *no* characters, *no* plot, *no* story, if possible *no* punctuation: a novel that came to be called the *anti-novel*.

A curious thing: the people who created modern poetry did not claim to be making *anti-poetry*. On the contrary, from Baudelaire on, poetic modernism was seeking a radical way to get at the essence of poetry, its most profound specificity. In this same way I imagined the modern novel not as an *anti*-novel but an *arch*-novel. The *arch*-novel would, primo, focus on what only the novel can say; and secundo, it would revive all the neglected and forgotten possibilities the art had accumulated over

the four centuries of its history. Twenty-five years ago I read your *Terra Nostra*; what I was reading there was an arch-novel. It was proof that such a thing existed, could exist. The great modernity of the novel. Its fascinating and difficult newness.

I embrace you, Carlos!

MILAN

The Total Rejection of Heritage, or Iannis Xenakis (a text published in 1980, with two interventions from 2008)

1

IT WAS TWO OR THREE YEARS AFTER THE RUSSIAN INVA-sion of Czechoslovakia. I fell in love with the music of Edgard Varèse and Iannis Xenakis.

I wonder why. Out of avant-garde snobbery? In the solitary life I was living at the time, snobbery would have made no sense. Out of an expert's interest? I might, with some effort, understand a piece by Bach, but faced with Xenakis's music I was completely unprepared, unschooled, uninitiated, an utterly naive listener. And yet I felt genuine pleasure at hearing his works, and I would listen avidly. I needed them: they brought me some strange consolation.

Yes, the word slipped out: I found consolation in Xenakis's music. I learned to love it during the darkest time of my life, and that of my homeland.

But why did I seek consolation in Xenakis rather than in the patriotic music of Smetana, where I could have found the illusion of perennial life for my country, which had just gotten a death sentence?

The disenchantment brought on by the catastrophe that had

struck my country (a catastrophe whose consequences will be felt for centuries) was not only about political events: the disenchantment was about man as man, man with his cruelty but also with the alibi he uses to disguise that cruelty, man always quick to justify his barbarity by his feelings. I was seeing that sentimental agitation (in private life as well as public) is not antithetical to brutality, but rather, merges with it, is part and parcel of it. . . .

(1980)

2

IN 2008 I ADD:

Reading my old text, seeing the phrases "my nation had just gotten a death sentence" and "the catastrophe that had struck my country . . . and whose consequences will be felt for centuries," I felt a spontaneous urge to obliterate them, since these days they can only seem absurd. Then I got a grip on myself. And I even found it rather disturbing that my memory should think to censor itself. Such are the Splendors and Miseries of memory: it is proud of its ability to keep truthful track of the logical sequence of past events; but when it comes to how we experienced them at the time, memory feels no obligation to truth. Thinking to suppress those few lines, memory did not feel guilty of any lie. It may have considered lying, but wasn't it in the name of truth? Because after all, isn't it clear now that in the meantime history has made the Russian occupation of

Czechoslovakia into just an episode that the world has already forgotten?

Of course. Still, I and my friends did experience that episode as a hopeless catastrophe. And if we forget our state of mind back then, there is no way to understand anything, neither the feel of that time nor its consequences. Our despair was not about the Communist regime. Regimes come and go. But the borders of civilizations endure. And we saw ourselves being swallowed up by a very different civilization. Inside the Russian empire so many other nations were in the process of losing even their language, their identity. And I realized the obvious fact (the *astoundingly obvious fact*): that the Czech nation is not immortal; that it too could cease to exist. Without that obsessing thought, my strange attachment to Xenakis would be incomprehensible. His music reconciled me to the inevitability of endings.

3

1980 TEXT RESUMED:

Á propos of sentiment as a justification for human cruelty, I recall a remark from Carl Gustav Jung. In his analysis of *Ulysses* he calls James Joyce "the prophet of unfeelingness": We have, he writes, "a good deal of evidence to show that we actually are involved in a sentimentality hoax of gigantic proportions. Think of the lamentable role of popular sentiment in wartime! . . . Sentimentality is the superstructure erected upon brutality. . . . I am deeply convinced that we . . . are caught in our

own sentimentality. . . . It is therefore quite comprehensible that a prophet should arise to teach our culture a compensatory lack of feeling."

Although a "prophet of unfeelingness," James Joyce could go on being a novelist. I even think that he could have found the forerunners of his "prophecy" in the history of the novel. The novel as an aesthetic category is not necessarily bound to a sentimental conception of man. Music, however, cannot avoid such a conception.

Despite Stravinsky's denial that music expresses feeling, the naive listener cannot see it any other way. That is music's curse, its mindless aspect. All it takes is a violinist playing the three long opening notes of a largo, and a sensitive listener will sigh, "Ah, how beautiful!" In those three notes that set off the emotional response, there is nothing, no invention, no creation, nothing at all: it's the most ridiculous "sentimentality hoax." But no one is proof against that perception of music, or against the foolish sigh it stirs.

European music is founded on the artificial sound of a note and of a scale; in this it is the opposite of the *objective* sound of the world. Since its beginnings, Western music is bound, by an insurmountable convention, to the need to express *subjectivity*. It stands against the harsh sound of the outside world just as the sensitive soul stands against the insensibility of the universe.

But the moment could come (in the life of a man or of a civilization) when sentiment (previously considered a force that makes man more human and that relieves the coldness of his

reason) is abruptly revealed as the "superstructure of brutality," ever present in hatred, in vengeance, in the fervor of bloody victories. At that time I came to see music as the deafening noise of the emotions, whereas the world of noises in Xenakis's works became beauty; beauty washed clean of affective filth, stripped of sentimental barbarity.

4

IN 2008 I ADD:

By pure coincidence, in these days when I'm thinking about Xenakis, I happen to read the book of a young Austrian writer, Thomas Glavinic's *Night Work*. A thirty-year-old man, Jonas, awakes one morning to find the world around him empty, without humans; his apartment, the streets, the stores, the cafés—everything is there, unchanged, just as before, with all the traces of the people who just yesterday inhabited it but are there no longer. The book describes Jonas's wanderings through this abandoned world, on foot and then aboard various vehicles that he keeps changing, since they're all standing driverless, available. For a few months, until he kills himself, he moves through the world looking desperately for traces of his life, his own memories, even other people's memories. He looks at houses, châteaus, forests, and thinks about the countless generations who used to see those things and who are gone now; and he understands that everything he is seeing is oblivion, pure oblivion, the oblivion whose absolute state will soon be achieved,

the moment he himself is gone. And again I think the obvious idea (that *astoundingly obvious idea*) that everything that exists (nation, thought, music) can also not exist.

5

1980 TEXT RESUMED:

Even being a "prophet of unfeelingness," Joyce was able to remain a novelist; Xenakis, on the other hand, had to *leave music*. His innovation was different in nature from that of Debussy or of Schoenberg. Those two never lost their ties to the history of music, they could always "go back" (and they often did). For Xenakis, the bridges had been burned. Olivier Messiaen said as much: Xenakis's music is "not radically new but radically other." Xenakis does not stand against some *earlier phase* of music; he turns away from all of European music, from *the whole of its legacy*. He locates his starting point somewhere else: not in the artificial sound of a note separated from nature in order to express a human subjectivity, but in the noise of the world, in a "mass of sound" that does not rise from inside the heart but instead comes to us from the outside, like the fall of the rain, the racket of a factory, or the shouts of a mob.

His experiments on sounds and noises that lie beyond notes and scales—can they become the basis of a new period in music history? Will his music live for long in music lovers' memory? Not very likely. What will remain is the act of enormous rejection: for the first time someone has dared to tell European

music that it can be abandoned. Forgotten. (Is it only chance that in his youth, Xenakis saw human nature as no other composer ever did? Living through the massacres of a civil war, being sentenced to death, having his handsome face forever scarred by a wound . . .) And I think of the necessity, of the deep meaning of this necessity, that led Xenakis to side with the objective sound of the world against the sound of a soul's subjectivity.

V.

BEAUTIFUL LIKE A
MULTIPLE ENCOUNTER

A Legendary Encounter

IN 1941, AS HE WAS EMIGRATING TO THE UNITED STATES, André Breton stopped off in Martinique; the French Vichyite administration there interned him for a few days; upon his release he was strolling through Fort-de-France when in a small variety shop he came upon a local literary journal, *Tropiques*; he was dazzled by it; at that baleful moment in his life it shone like the light of poetry and courage. He quickly came to know the editorial team, a few young people in their twenties organized around the poet Aimé Césaire, and he spent all his time with them. Pleasure and encouragement for Breton, aesthetic inspiration and unforgettable fascination for those Martinicans.

Several years later, on his way home to France in 1945, Breton stopped briefly in Port-au-Prince, Haiti, where he gave a lecture. All the island's intellectuals attended, among them the very young writers Jacques Stephen Alexis and René Depestre. They listened to him, as fascinated as the Martinicans had been a few years earlier. Their journal, *La Ruche* (again a journal! yes, that was the great era of literary journals, an era that exists no longer), devoted a special issue to Breton; the issue was confiscated and the journal outlawed.

For the Haitians the encounter was as unforgettable as it was brief. I've said "encounter": not a social relation, not a friendship,

not even an alliance: an encounter, which is to say a spark; a lightning flash; random chance. Alexis was twenty-three at the time, Depestre nineteen; they had only a very superficial acquaintance with Surrealism, knowing nothing, for instance, about its politics (the schisms inside the movement); intellectually both avid and inexperienced, they were captivated by Breton, by his rebellious stance, by the freedom of imagination that his aesthetic called for.

In 1946 Alexis and Depestre established the Haitian Communist Party, and their writing was revolutionary in orientation; at the time that sort of literature was common the world over, under the obligatory influence of Russia and its "socialist realism." For the Haitians, though, the master was not Gorky but Breton. They were not talking about socialist realism; their watchword was the literature "of the marvelous," or "magical realism." Soon Alexis and Depestre were forced to leave the country. Then in 1961 Alexis returned to Haiti intending to take up the struggle again. He was arrested, tortured, and killed. He was thirty-nine years old.

Beautiful Like a Multiple Encounter

AIMÉ CÉSAIRE: HE IS THE GREAT FOUNDING FIGURE: THE founder of Martinican *politics*, which had not existed before him. But he is also the founder of Martinican *literature*: his *Notebook of a Return to the Native Land* (an utterly original poem I can compare to nothing else, and according to Breton

"the greatest lyrical monument of its time") is as foundational for Martinique (and indeed for all the Antilles) as the works of Mickiewicz (1798–1855) are for Poland, or the poetry of Petőfi (1823–49) for Hungary. In other words, Césaire is doubly a founding figure: two innovations (the political and the literary) meet in his one person. But, unlike Mickiewicz or Petőfi, he is not only a founding poet, he is also a *modern poet*, heir to Rimbaud and Breton. Two separate epochs (the beginning and the apogee) come together marvelously in his work.

The journal *Tropiques*, whose nine issues were published between 1941 and 1945, deals systematically with three main subjects that, set side by side, themselves constitute an extraordinary encounter, one that has never occurred in any other avant-garde journal in the world:

1. *Martinican emancipation, both cultural and political:* consideration of African culture, particularly that of black Africa; investigation into the history of slavery; the early stages of thinking on "negritude" (it was Césaire who coined the term, defiantly, spurred by the disdainful connotation of the word "negro"); the panorama of Martinique's cultural and political situation; anticlerical and anti-Vichy polemics;

2. *pedagogy on modern poetry and modern art:* a celebration of the heroes of modern poetry: Rimbaud, Lautréamont, Mallarmé, Breton; starting with the third issue, a full-blown Surrealist orientation (we should point out that, although strongly politicized, these youngsters do not sacrifice poetry to politics: for them Surrealism is primarily an art movement); their identification with Surrealism is boyishly

passionate: "the marvelous is always beautiful, anything marvelous is beautiful, in fact only the marvelous is beautiful," Breton said, and the word "marvelous" became a catchword for them; the syntactical model of Breton's sentences ("beauty will be convulsive or will not be at all") is often imitated, as is that of Lautréamont's phrase ("beautiful like the chance encounter on a dissection table of a sewing machine with an umbrella . . ."); says Césaire: "Lautréamont's poetry, beautiful like an expropriation decree" (and Breton himself: "the voice of Aimé Césaire beautiful like newborn oxygen"); and so on.

3. *the foundation of Martinican patriotism:* the desire to embrace the island as home, as a fatherland that one should know in depth: a long article on the fauna of Martinique, another on its plant life, but especially folk art: publication of and commentary on Creole folktales.

On the subject of folk art: in Europe it was taken up by the romantics: Brentano, Arnim, the brothers Grimm, and Liszt, Chopin, Brahms, Dvořák; there is a view that folk music lost its appeal for the modernists, but that is an error: not only Bartók and Janáček but also Ravel, Milhaud, de Falla, Stravinsky; all of them loved this music, in which they discovered forgotten tonalities, unfamiliar rhythms, a harshness and immediacy that concert-hall music had long since lost; unlike the romantics, folk art confirmed the modernists in their aesthetic nonconformity. The position of the Martinique artists is similar: for them the fantastical aspect of folktales blended with the freedom of imagination propounded by the Surrealists.

Encounter of an Umbrella in Perpetual Erection with a Sewing Machine for Uniforms

DEPESTRE: I READ HIS 1981 STORY COLLECTION WITH ITS symptomatic title, *Hallelujah for a Woman-Garden.* Depestre's eroticism: all women overflow with so much sexuality that even the traffic lights are aroused and twist around to watch them pass. And the men are so randy that they're ready to make love during a scientific conference, during a surgical operation, inside a spaceship, on a trapeze. All for pure pleasure; there are no problems psychological, moral, or existential; we're in a universe where vice and innocence are one and the same. Usually this sort of lyrical intoxication bores me; if anyone had described Depestre's books before I read them, I would never have opened them.

Fortunately I read them without knowing what I was in for, and the best thing that can ever happen to a reader happened to me: I loved something that, by conviction (or by my nature), I should not have loved. If someone just slightly less talented than he had tried to express that same thing, he would only have come up with a cartoon; but Depestre is a real poet or, to say it the Antillean way, a true master of the marvelous: he has managed to put onto mankind's existential map something that was not there before: the nearly inaccessible borderlands of happy, naive eroticism, of unbridled and paradisal sexuality.

Then I go on to read other stories by him, from the collection titled *Eros in a Chinese Train,* and I linger over a few set in the

Communist countries that had opened their arms to this revolutionary figure banished from his own land. With astonishment and tenderness, I ponder this Haitian poet, his head stuffed with crazy erotic fantasies, wandering the Stalinian desert in its worst years, when an unbelievable puritanism reigned and when the least erotic liberty could cost dearly.

Depestre and the Communist world: the encounter of an umbrella in perpetual erection with a sewing machine for making uniforms and shrouds. He recounts his amorous adventures: with a Chinese woman who because of one night of love is banished for nine years to a Turkestan leper colony; with a Yugoslav girl who just escaped having her head shaved, like all Yugoslav women at the time who were found guilty of sleeping with a foreigner. I read these few stories today and, abruptly, our whole century strikes me as unreal, improbable, as if it were just the black fantasy of a black poet.

The Night World

"IN THE SLAVE PLANTATIONS OF THE CARIBBEAN AFRIcans existed in two worlds. There was the world of the day; that was the white world. There was the world of the night; that was the African world, of spirits and magic and the true gods. And in that world ragged men, humiliated by day, were transformed—in their own eyes, and the eyes of their fellows—into kings, sorcerers, herbalists, men in touch with the true forces of the

earth and possessed of complete power. . . . To the outsider, to the slave owner, the African night world might appear a mimic world, a child's world, a carnival. But to the African . . . it was the true world: it turned white men to phantoms and plantation life to an illusion."

After reading these words of V. S. Naipaul, who also came from the Antilles, I suddenly realized that Ernest Breleur's paintings are all night pictures. Night is their sole setting, the only one that could show "the real world" on the other side of the deceptive daytime. And I understood that these paintings could only be born here, in the Antilles, where the slave past is still etched in pain on what used to be called "the collective unconscious."

And yet, while the very earliest period of his work is purposely anchored in the culture of Africa, while I discern in it certain motifs taken from African folk art, the later periods are more and more personal, free of any program. And this is the paradox: it is precisely in this extremely personal painting that the black identity of a man of Martinique is present in all its dazzling display: this work is, first, the world of the night kingdom; second, it is the world where everything is transformed into myth (everything, each tiny ordinary object, including Ernest's little dog, which appears in so many pictures, changed into a mythological animal); and third, it is the world of cruelty, as if the ineradicable past of slavery returns as an obsession with the body: the body in pain, the body tortured and torturable, woundable and wounded.

Cruelty and Beauty

WE ARE DISCUSSING CRUELTY, AND I HEAR BRELEUR SAY, in his calm voice: "No matter what, in painting the main thing must be beauty." Which, to my mind, means: art must always guard against stirring emotions that lie outside the aesthetic: sexual arousal, terror, disgust, shock. A photograph of a naked woman pissing could give a man an erection, but I don't believe he could get the same charge from Picasso's *La pisseuse*, though it's a mightily erotic painting. We turn our eyes away from a film about a massacre, whereas the eye delights in the sight of *Guernica*, the painting that depicts the same atrocity.

Headless bodies, suspended in space—these are Breleur's latest pictures. Then I look at their dates: as his work on this cycle proceeds, the theme of the body left hanging in the void loses its original traumatic effect, the mutilated body tossed into the void suffers less and less; from one image to the next it comes to resemble an angel lost amid the stars, or a magical invitation arriving from afar, or a carnal temptation, or a playful acrobatics. Over the course of countless variants, the original theme shifts from the realm of cruelty to the realm (to reuse this catchword) of the marvelous.

With us in the studio are my wife, Vera, and Alexandre Alaric, a Martinican philosopher. As always before the meal, we are drinking a punch. Then Ernest prepares the lunch. On the table six places are set. Why six? At the last moment in

comes Ismael Mundaray, a Venezuelan painter; we begin to eat. But strangely the sixth setting lies intact right to the end of the meal. Much later Ernest's wife comes home from work, a beautiful and—it's instantly clear—beloved woman. We leave in Alexander's car; Ernest and his wife stand in front of their house gazing after us. I get the sense of a couple in anxious union, surrounded by an inexplicable aura of loneliness. "You understand the mystery of that sixth setting," says Alexandre when we are out of their sight: "It gave Ernest the illusion that his wife was with us."

Home and the World

"I SAY WE ARE SMOTHERING. THE PRINCIPLE OF A HEALTHY Antillean politics: Open the windows. Air. Air," Césaire wrote in 1944, in the journal *Tropiques.*

Open the windows toward which direction?

First of all toward France, says Césaire; for France is the Revolution, it's the great abolitionist Schoelcher, and it's also Rimbaud, Lautréamont, Breton; it is a literature and a culture worthy of the greatest love. Next, open them toward the African past, a past amputated, confiscated, that holds the buried essence of the Martinican personality.

Later generations would often dispute Césaire's Franco-African orientation, insisting on the Americanness of Martinique; on its *"créolité"* (connoting the whole array of skin colors

and a language of its own); on its bonds with the Antilles and with all of Latin America.

Because every people in search of itself thinks about where to locate the margin between its own home and the rest of the world, the location of what I call the *median context*, the realm between national and global contexts. For a Chilean that median context would be Latin America; for a Swede, it is Scandinavia. Obviously. But what about Austria? Where was that margin located? In the Germanic world? Or in the world of multinational Central Europe? The whole meaning of Austria's existence depended on the response to that question. When, after 1918 and then still more radically after 1945, it had left the context of Central Europe, it turned back into itself or into its Germanness, it ceased to be that shining Austria of Freud or Mahler, it was a different Austria, and with far more limited cultural influence. The same dilemma faced Greece, which inhabits both the world of Eastern Europe (Byzantine tradition, Orthodox Church, Russophile orientation) and the world of Western Europe (Greek-Latin tradition, strong bond to the Renaissance, and modernity). In impassioned polemics the Austrians or the Greeks can argue for one orientation over another, but with a little detachment we would say: there are some nations whose identity is characterized by duality, by the complexity of their median context, and that's precisely what gives them their particularity.

As to Martinique, I would say the same thing: the coexistence of various different median contexts there is what makes for the particularity of its culture. Martinique: a multiple inter-

section; a crossroads among the continents; a tiny slip of land where France, Africa, the Americas meet.

Yes, that's beautiful. Very beautiful, except that France, Africa, America don't much care. In today's world the voice of small entities is barely heard.

Martinique: the encounter of a great cultural complexity with a great solitude.

The Language

MARTINIQUE IS BILINGUAL. THERE IS CREOLE, THE EVERY-day language born in the time of slavery, and (as in Guadeloupe, Guyana, Haiti) there is the French language taught in school, and mastered by the intelligentsia to a nearly vindictive perfection. (Césaire "handles the French language as no white man today handles it," Breton declared.)

When Césaire was asked, in 1978, why the journal *Tropiques* was not written in Creole, he answered: "The question makes no sense, because this kind of journal is not conceivable in Creole. . . . What we have to say, I don't even know whether it could be articulated in Creole. . . . Creole is incapable of expressing abstract ideas; . . . it is solely an oral language."

Nonetheless it is a delicate task to write a Martinican novel in a tongue that does not embrace the whole reality of daily life. Possible solutions: a novel in Creole; a novel in French; a novel in French enriched by Creole words explained in footnotes; and then, the solution of Patrick Chamoiseau:

He has taken liberties with French that no writer in France could even imagine daring to take. It is like a Brazilian writer's liberty with Portuguese, a Spanish American writer with Spanish. Or, yes, the liberty of a bilingual writer who refuses to grant absolute authority to one or the other of his languages, and has the courage to disobey. Chamoiseau did not reach some compromise between French and Creole by mixing them together. His language is French, but French transformed; it is not creolized (no Martinican talks like that), it is Chamoisized: he gives it the delightful insouciance of the spoken language, its cadence, its melody; he brings in many Creole expressions, not for the sake of "naturalism" (to introduce bits of "local color"), but for *aesthetic* reasons (for their funniness, their charm, or their semantic irreplaceability). But mainly he has given his French the freedom of unaccustomed, casual, "impossible" turns of phrase, the freedom of neologisms (a freedom the highly normative French language enjoys much less than other languages): he casually transforms adjectives into nouns (*maximalité, aveuglage*), verbs into adjectives (*éviteux*), adjectives into adverbs (*malement, inattendument*) ("*Inattendument?* Césaire already made that word legitimate in his *Notebook on a Return to my Native Land*," Chamoiseau protests), verbs into nouns (*égorgette, raterie, émerveille, disparaisseur*), nouns into verbs (*horloger, riviérer*), and so on. And he does this without all these transgressions diminishing the lexical or grammatical richness of the French (there is no shortage of either bookish or archaic words, and plenty of imperfect subjunctive).

The Encounter Across Centuries

AT FIRST GLANCE *SOLIBO MAGNIFICENT* COULD LOOK LIKE an exotic, local novel, focused on a character unimaginable elsewhere: a folk storyteller. Wrong: Chamoiseau's novel deals with one of the greatest events in the history of culture: the encounter between oral literature in its last hours and written literature as it is being born. In Europe this encounter occurred in Boccaccio's *Decameron*. Without the practice (still alive at the time) of storytellers entertaining an audience, this first great work of European prose could not exist. Later, until the end of the eighteenth century, from Rabelais to Laurence Sterne, the echo of the storyteller's voice continued to sound in novels; writing, the writer was *speaking* to the reader, addressing him, insulting him, flattering him; in turn, reading, the reader was also *hearing* the novel's author. It all changed at the start of the nineteenth century; that is the beginning of what I call the "second period"* of the novel's history: the writer's *spoken word* disappears behind the writing.

"Hector Bianciotti, this word is for you," says the dedication of *Solibo Magnificent*. Chamoiseau emphasizes: the spoken

* "First" and "second" periods: I discuss this (entirely personal) idea of periodization in the history of the novel (and in the history of music as well) in *Testaments Betrayed*, particularly in part 3, "Improvisation in Homage to Stravinsky." Very schematically: the first period of the novel's history ends, in my view, at roughly the end of the eighteenth century. The nineteenth century inaugurates a different aesthetic for the novel, one far more obedient to the rules of plausibility. The modernism of the novel, as it breaks free of the dogmas of that "second" period, could, if one agrees to that idea (strictly my own), be called the "third" period.

word, not the writing. He sees himself as the direct heir of the storytellers, he calls himself not a writer but "a word scratcher, a person who sets down talk." On the map of the supranational history of culture, he means to locate himself at the juncture where the word pronounced aloud passes the baton to written literature. In his novel the imaginary storyteller named Solibo tells him that: "I talked, but you, you write and declare that you come from the spoken word." Chamoiseau is the writer coming from the spoken word.

But just as Césaire is not Mickiewicz, Chamoiseau is not Boccaccio. He is a writer with all the refinement of the modern novel, and it is as such (as a grandson of Joyce or of Broch) that he reaches out a hand to Solibo, to that oral prehistory of literature. *Solibo Magnificent* is thus an encounter across centuries. "You give me your hand over a distance," Solibo tells Chamoiseau.

The story of *Solibo Magnificent*: on an open space called Savanna in the town of Fort-de-France, Solibo is talking before a small audience (Chamoiseau is among them) gathered there at random. In the midst of his discourse he dies. The old Negro, Congo, knows what happened: Solibo has died from the word slitting his throat. This explanation is not very convincing to the police, who instantly latch on to the incident and break their backs to uncover the murderer. There ensue some nightmarishly cruel interrogations during which the character of the dead storyteller takes form before us and two suspects die under torture. At the end the autopsy rules out murder: Solibo died in some unexplained fashion: maybe, actually, from the word slitting his throat.

In the last pages of the book, the author publishes Solibo's discourse, the one during which he fell down dead. This imaginary discourse, true poetry, is an initiation into the aesthetic of the oral tradition. What Solibo tells is not a story, it is talk: words, speech, fantasy, wordplay. It is improvisation, it is *automatic talking* (like the Surrealists' "automatic writing"). And since it is talk, that is, "language before there was writing," the rules of writing do not apply: therefore, no punctuation: Solibo's discourse is a surge with no periods, no commas, no paragraphs, like Molly's long monologue at the end of *Ulysses*. (Another example demonstrating that folk art and modern art, at a certain moment of history, can reach out a hand to each other.)

The Improbable in Rabelais, Kafka, Chamoiseau

What I especially like about Chamoiseau is his imagination, oscillating between the probable and the improbable, and I wonder where it comes from, what are its roots?

Surrealism? The Surrealists' imagination developed mainly in poetry and painting. Whereas Chamoiseau is a novelist, a novelist and nothing but.

Kafka? Yes, he did make the improbable legitimate for the art of the novel. But the nature of the imagination in Chamoiseau is not very Kafkaesque.

"Ladies and gentlemen here present": this is how Chamoiseau starts his first novel, *Chronicle of the Seven Sorrows*. He addresses the readers of *Solibo* several times with "O friends."

This recalls Rabelais, who begins his *Gargantua* with the apostrophe: "Very illustrious drinkers, and you, precious pox-ridden ... " Someone who speaks to his reader aloud this way, who invests every phrase with his wit, his humor, his displays, can easily exaggerate, mystify, slip from the real to the impossible, for such was the contract between novelist and reader in that "first period" of the novel's history, when the storyteller's voice was not yet completely obscured behind printed characters.

With Kafka we are in a different piece of the novel's history; in his work the improbable is supported by description; it is utterly impersonal and so very evocative that the reader is drawn into an imaginary world as if it were a film: even though nothing about it resembles our own experiences, the power of the description makes it all believable. In this kind of aesthetic the voice of a raconteur talking, joking, commenting, showing off would break the spell. It is impossible to imagine Kafka starting *The Castle* by cheerily addressing his readers: "Ladies and gentlemen here present."

In Rabelais, on the other hand, the improbable comes from nothing but the raconteur's offhand style. Panurge chases after a lady, but she rebuffs him. To get even he smears her clothes with tissue from the sex organs of a bitch in heat. All the dogs in town storm the lady, they run after her, piss on her gown, on her legs, on her back; and when they reach her house they piss so thoroughly on her door that their urine runs down the street like a brook and ducks come to swim on it.

Solibo's corpse is laid upon the ground; the police try to move it to the morgue. But no one can manage to lift it; "Solibo had

begun to weigh a ton, like the corpses of those Negroes who go on yearning for life." They call for help; Solibo now weighs two tons, five tons. A crane is called. When it arrives Solibo starts losing weight. And the chief sergeant raises the body up with "the tip of his little finger. Finally he starts some slow macabre manipulations that fascinate everyone. With a few slight twists of the wrist he twirls the cadaver, passing it from his little finger to his thumb, from the thumb to the index finger, from the index to the middle finger. . . ."

O ladies and gentlemen here assembled, most valiant and illustrious drunks, precious pox-ridden comrades, with Chamoiseau you are much nearer to Rabelais than to Kafka.

Alone Like the Moon

IN ALL BRELEUR'S PAINTINGS THE MOON, CRESCENT-shaped, lies horizontally with the two tips pointed up, like a gondola floating on the swells of the night. This is not the painter's fantasy, it's how the moon actually is in Martinique. In Europe the crescent moon stands upright: combative, like a fierce little animal set on its haunches ready to spring or, if you prefer, like a perfectly sharpened scythe; the moon in Europe is the moon of war. In Martinique it is peaceable. That may be why Ernest gives it a warm golden color; in his mythic pictures it represents an unattainable happiness.

Bizarre: I mention this to some Martinicans, and I notice that they don't know what the moon actually looks like up

in the sky. I ask Europeans: do you remember the moon in Europe? What is its shape when it is rising, when it is setting? They don't know. Man no longer looks at the sky.

Neglected, the moon has come to rest in Breleur's paintings. But the people who no longer see it in the sky will not see it in the paintings either. You are alone, Ernest. Alone like Martinique amid the seas. Alone like Depestre's concupiscence in the monastery of Communism. Alone like a van Gogh painting before the imbecile stares of tourists. Alone like the moon nobody sees.

(1991)

VI.

Elsewhere

Exile as Liberation According to Vera Linhartova

IN THE 1960S VERA LINHARTOVA WAS ONE OF THE MOST admired writers in Czechoslovakia, the poetess of a prose that was meditative, hermetic, beyond category. Having left the country for Paris after 1968, she began to write and publish in French. Known for her solitary nature, she astonished all her friends when, in the early 1990s, she accepted the invitation of the French Institute of Prague and, on the occasion of a colloquium on the issue of exile, she delivered a paper. I have never read anything on the subject more nonconformist and more clearsighted.

The second half of the past century has made everyone extremely sensitive to the fate of people forced out of their own homelands. This compassionate sensitivity has befogged the problem of exile with a tear-stained moralism, and obscured the actual nature of life for the exile, who according to Linhartova has often managed to transform his banishment into a liberating launch "toward another place, an elsewhere, by definition unknown and open to all sorts of possibilities." Of course she is right a thousand times over! Otherwise how are we to understand the fact that after the end of Communism, almost none of the great émigré artists hurried back to their home countries? Why was that? Did the end of Communism not spur them to celebrate the "Great Return" in their native lands? And even

if, despite the disappointment of their audience, that return was not what they wanted, wasn't it their moral obligation? Said Linhartova: "The writer is above all a free person, and the obligation to preserve his independence against all constraints comes before any other consideration. And I mean not only the insane constraints imposed by an abusive political power, but the restrictions—all the harder to evade because they are well-intentioned—that cite a sense of duty to one's country." In fact people chew over clichés about human rights, and at the same time persist in considering the individual to be the property of his nation.

She goes further still: "So I chose the place where I wanted to live, but I have also chosen the language I wanted to speak." People will protest: sure, a writer is a free person, but is he not the custodian of his language? Isn't that the very meaning of a writer's mission? Linhartova: "It is often asserted that a writer has less freedom of movement than anyone else, for he remains bound to his language by an indissoluble tie. I believe this is another of those myths that serve as excuse for timid folks." For: "The writer is not a prisoner of any one language." A great liberating sentence. Only the brevity of life keeps a writer from drawing all the conclusions from this invitation to freedom.

Linhartova: "My sympathies lie with the nomads, I haven't the soul of a sedentary myself. So I am now entitled to say that my own exile has fulfilled what was always my dearest wish: to live elsewhere." When Linhartova writes in French, is she still a Czech writer? No. Does she become a French writer? No, not that either. She is elsewhere. Elsewhere as Chopin was

in his time, elsewhere as, later, each in his own fashion, were Nabokov, Beckett, Stravinsky, Gombrowicz. Of course each of them lived his exile in his own inimitable way, and Linhartova's experience is an extreme case. Yet after her radical, luminous declaration, we can no longer speak of exile as we have done up till now.

The Untouchable Solitude of a Foreigner (Oscar Milosz)

1

THE FIRST TIME I SAW THE NAME OSCAR MILOSZ, IT WAS over the title of his *November Symphony*, translated into Czech and published a few months after World War II in an avant-garde journal I used to read assiduously at the age of seventeen. How thoroughly that poetry had entranced me I understood some thirty years later in France, where for the first time I was able to open the volume of Milosz's poetry in its original French. I quickly looked up *November Symphony*, and as I read it I heard in memory the whole (superb) Czech translation of this poem, not one word of which have I forgotten. In that Czech version Milosz's poem marked me perhaps more profoundly than other poetry I was devouring at that same period, that of Apollinaire or Rimbaud or Desnos or Vitezslav Nezval. Beyond a doubt these poets had amazed me not only with the beauty of their verses but also by the myth surrounding their sacred names, which served as passwords to get myself recognized among my own people, the moderns, the initiated. But there was no myth around Milosz: his totally unknown name said nothing to me, and nothing to anyone around me. In his case I was entranced not by a myth but by a beauty acting on its own, alone, naked, with no outside support. Let's be honest: that rarely happens.

2

BUT WHY THIS POEM IN PARTICULAR? THE ESSENTIAL REASON, I think, lay in the discovery of something I had never encountered anywhere else: I discovered the archetype of a form of nostalgia that is expressed, grammatically, not by the past but by the future: the *grammatical future of nostalgia*. The grammatical form that projects a lamented past into a distant future, that transforms the melancholy evocation of a thing that no longer exists into the heartbreaking sorrow of a promise that can never be realized.

> *You will be all in pale violet, beautiful grief*
> *And the flowers on your hat will be sad and small*

3

I REMEMBER A PERFORMANCE OF RACINE AT THE COMÉDIE-Française. To make the lines sound natural, the actors recited them as if they were prose, systematically suppressing the pause at the end of the lines; impossible to recognize the alexandrine rhythm or hear the rhymes. Perhaps they thought they were behaving according to the spirit of modern poetry, which has long since abandoned meter and rhyme. But free verse, at its birth, was not trying to make poetry into prose! It was trying to rid poetry of the armorplate of meter and discover a different

musicality, a richer and more natural one. My ears will always retain the singing voices of the great Surrealist poets (Czech as well as French) reciting their own verses! Like an alexandrine, a free-verse line was also an uninterrupted musical unit, ending in a pause. The pause must be made audible, in free verse as well as in an alexandrine line, even if that seems to contradict the grammatical logic of the sentence. That pause breaking the syntax is the heart of the melodic refinement (the melodic provocation) of the enjambment. The doleful melody of Milosz's *Symphonies* is grounded in the sequence of enjambments. An enjambment in Milosz is a brief startled silence before the word that will come at the start of the next line:

> *And the murky path will be there, all damp*
> *With an echo of cascades. And I shall speak to you*
> *Of the city on the water and of the Bacharach Rabbi*
> *And of Florentine Nights. There will be as well . . .*

4

IN 1949 ANDRÉ GIDE EDITED AN ANTHOLOGY OF FRENCH poetry for Gallimard Publishers. In the preface he wrote, "X complains that I put in nothing by Milosz. Was that by oversight? Not at all. It is because I found nothing that seemed to me especially worth including. I repeat: my selection was not intended to be historical; I select by quality alone." There was

an element of good sense in Gide's arrogance: Oscar Milosz had no business in that anthology; his poetry is not French; retaining all his Polish Lithuanian roots, he took refuge in the language of the French people as if in a Carthusian monastery. So we may consider Gide's rejection a noble way of protecting the untouchable solitude of a foreigner; of a Stranger.

Enmity and Friendship

ONE DAY EARLY IN THE 1970S, DURING THE RUSSIAN OCCU-
pation of our country, both of us fired from our jobs, both of us
in poor health, my wife and I went to a hospital in the Prague
suburbs to see a great doctor, friend to all the dissidents, an old
Jewish wise man as we called him, Professor Smahel. There
we ran into E., a journalist who had also been run out of ev-
erywhere, who was also in poor health, and the four of us sat
and talked for a long time, happy in the atmosphere of fellow
feeling.

E. gave us a lift back into town and began to talk about
Bohumil Hrabal, who was at the time the greatest living Czech
writer: a man of boundless fantasy, passionately interested in
plebeian experience (his novels are filled with the most ordinary
people), he was much read and much loved (the whole wave of
young Czech filmmakers worshipped him as its patron saint).
He was profoundly apolitical. In a regime for which "every-
thing was political," this was not innocent: his apolitical stance
mocked the world where ideologies ran riot. For that reason he
lived for a long while in relative disgrace (unusable as he was
for any official assignment), but also for the very reason of that
apolitical stance (neither did he speak out against the regime),
he was left alone during the Russian occupation and he man-
aged, one way and another, to publish a few books.

E. raged against him: How could he allow his books to be printed while his colleagues were forbidden to publish? How could he validate the regime that way? Without a word of protest? His behavior is detestable, Hrabal is a collaborator.

I reacted with the same rage: What absurdity to speak of collaboration when the spirit of Hrabal's books, their humor, their imagination, are the absolute opposite of the mentality ruling over us, trying to strangle us with their straitjacket! A world where a person can read Hrabal is utterly different from a world where his voice could not be heard! One single book by Hrabal does more for people, for their freedom of mind, than all the rest of us with our actions, our gestures, our noisy protests! The discussion in the car turned quickly into a bitter quarrel.

Thinking about it later, astounded by that hatred (authentic, and completely reciprocal), I said to myself: our harmony in the doctor's office was transitory, connected to a particular set of historical circumstances that made us all victims of persecution; our disagreement, though, was fundamental, independent of circumstances; it was the disagreement between people for whom the political struggle is more important than real life, than art, than thought, and people for whom the whole meaning of politics is to serve real life, art, thought. These two attitudes may each of them be legitimate, but they are irreconcilable.

In the autumn of 1968 I spent two weeks in Paris, and was fortunate to have two or three long conversations with Louis Aragon in his apartment on the rue de Varennes. No, I did not tell him much; I listened. I have never kept a journal, so my

recollections are vague: of his remarks I recall only two recur-
ring themes: he talked a good deal about André Breton, who,
toward the end of his life, was apparently in contact again, and
he talked about the art of the novel. Even in his preface to my
book *The Joke* (which he wrote a month before our meetings),
he had praised the art of the novel as such: "The novel is indis-
pensable to man, like bread"; in the course of my visits he kept
urging me always to defend "that art" (that "depreciated" art,
as he wrote in his preface; I later took up that expression for the
title of a chapter in my *Art of the Novel*).

Our meetings left me with the sense that the most signifi-
cant reason for his break with the Surrealists was not political
(his obedience to the Communist Party) but aesthetic (his loy-
alty to the novel, that art "depreciated" by the Surrealists), and I
felt I had glimpsed the double drama of his life: his passion for
the art of the novel (perhaps the most important area of his own
genius) and his friendship for Breton (today I know this: when
it comes time to take stock, the most painful wound is that of
broken friendships; and there is nothing more foolish than to
sacrifice a friendship to politics. I am proud never to have done
that. I admired Mitterrand for his loyalty to old friends. That
loyalty was the reason he was so violently attacked toward the
end of his life. That loyalty was his nobility.)

Some seven years after my encounter with Aragon, I made
the acquaintance of Aimé Césaire, whose poetry I had discovered
just after the war in Czech translation in an avant-garde journal
(the same journal that had introduced me to Milosz). This was in
Paris, in the atelier of the painter Wilfredo Lam. Aimé Césaire,

young, vivacious, charming, barraged me with questions. The very first one: "Kundera, did you know Nezval?" "Yes, of course. But you—how do you know him?" No, he had not known Nezval, but André Breton had talked a lot about him. According to my own preconceived notions, I would have thought that Breton, with his reputation as an intransigent man, could only have spoken ill of Vitezslav Nezval, who some years earlier had broken with the Czech Surrealists, choosing instead like Aragon to follow the dictates of the Party. And yet Césaire said again that when Breton was in Martinique in 1940, he spoke lovingly of Nezval. And I found that moving. All the more because, I remember well, Nezval too always spoke lovingly of Breton.

What shocked me most in the great Stalin trials was the cold approval with which the Communist statesmen accepted the execution of their friends. For they were all friends, by which I mean that they had known one another intimately, had lived together through rough times, emigration, persecution, a long political struggle. How is it that they were able to sacrifice their friendship, and in such a macabrely definitive way?

But was it friendship? There is a human relationship called *soudruzstvi* in Czech—from *soudruh*, comrade—meaning "the friendship of comrades or companions," the fellow-feeling that binds those who engage in the same political struggle. When the common devotion for the cause disappears, the reason for that fellow-feeling disappears as well. But friendship subordinated to an interest considered superior to friendship has nothing to do with friendship.

In our time people have learned to subordinate friendship

to what's called "convictions." And even with a prideful tone of moral correctness. It does take great maturity to understand that the opinion we are arguing for is merely the hypothesis we favor, necessarily imperfect, probably transitory, which only very limited minds can declare to be a certainty or a truth. Unlike the puerile loyalty to a conviction, loyalty to a friend is a virtue—perhaps the only virtue, the last remaining one.

I look at a photograph of the poet René Char alongside Heidegger. The one celebrated as a French *résistant* to the German occupation, the other denigrated for sympathizing with early Nazism at one point in his life. The photo dates from the postwar years. The two are pictured from the rear; with caps on their heads, one figure tall, the other short, they are taking a walk in the outdoors. I am very fond of that photo.

Faithful to Rabelais and to the Surrealists
Who Delved into Dreams

LEAFING THROUGH DANILO KIS'S OLD BOOK OF REFLEC-
tions, I feel I'm back in a bistro near the Trocadero, with him
across the table talking in his loud harsh voice as if he were
bawling me out. Of all the great writers of his generation,
French or foreign, who lived in Paris in the 1980s, he was the
most invisible. The Goddess of News had no reason to train her
klieg lights on him. "I'm not a dissident," he wrote. He wasn't
even an émigré. He traveled freely between Belgrade and Paris.
He was only a "bastard writer out of the swallowed-up world
of Central Europe." Swallowed up, yes, but over the course of
Danilo's life (he died in 1989) that world had been the con-
densation of the European story. Yugoslavia: a long bloody
(and victorious) war against the Nazis; the Holocaust that mur-
dered mainly the Jews of Central Europe (among them Da-
nilo's father); the Communist revolution, immediately followed
by Tito's dramatic (also victorious) split from Stalin and Stalin-
ism. As affected as he was by this historic drama, Danilo never
sacrificed his novels to politics. Thus he was able to grasp the
most harrowing aspects: individual fates no sooner born than
abandoned; tragedies with no vocal cords. He agreed with
Orwell's ideas, but how could he have loved *1984*, the novel in
which that scourge of totalitarianism reduced human life to its

political dimension alone, exactly as the Maos of the world were doing? Against that flattening of existence, Danilo called Rabelais to the rescue, with his drolleries, and the Surrealists, who "delved into the unconscious, into dreams." I leaf through his old book and I hear his loud harsh voice: "Unfortunately, the major-key tone of French literature that began with Villon—it's disappeared." Once he understood that, he became still more faithful to Rabelais, to the Surrealists "delving into dreams," and to a Yugoslavia that, blindfolded, was already on its way to disappearing as well.

On the Two Great Springs, and on the Škvoreckýs

1

IN SEPTEMBER 1968, TRAUMATIZED BY THE RUSSIAN invasion of Czechoslovakia, I was able to spend a few days in Paris; Josef and Zdena Škvorecký were there as well. I recall the image of some young man who said to us, in an aggressive tone: "Just what did you Czechs want, anyway? You were already sick of socialism?"

In those weeks we had long discussions with a circle of French friends who saw the two Springs of 1968—the French and the Czech—as related events, emanating the same rebellious spirit. That was a lot nicer to hear, but the misunderstanding persisted:

Paris's May '68 was an unexpected explosion. The Prague Spring was the culmination of a long process rooted in the shock of the Stalinist Terror in the early years after 1948.

Paris's May, brought about primarily by the initiative of the young, was marked by revolutionary lyricism. The Prague Spring was inspired by the postrevolutionary skepticism of adults.

Paris's May was a high-spirited challenge to a European culture viewed as deadening, tedious, official, sclerotic. The Prague Spring was an homage to that same European culture, so long smothered beneath ideological idiocy; it was a defense of Christian belief as well as of libertine unbelief, and of course of modern art (I stress "modern," not "postmodern").

The Paris May trumpeted its international character. The Prague Spring sought to give a small nation back its particularity and its independence.

By "marvelous chance" those two Springs—out of synch, the two coming from different historical experiences—met on the "dissection table" of the same year.

2

THE START OF THE ROAD TOWARD THE PRAGUE SPRING IS marked in my own memory by Škvorecký's first novel, *The Cowards*, published in 1956 and greeted by the glorious fireworks of official hatred. This novel, a great literary turning point, describes a great historical turning point: a week in May 1945 during which, after six years of German occupation, the Czech Republic was reborn. But why did the book arouse such hatred? Was it so aggressively anti-Communist? Not at all. In it Škvorecký tells the story of a man of twenty, mad about jazz (like Škvorecký), carried away by the whirlwind of the last few days of war when the German army was on its knees, the Czech resistance was, awkwardly, seeking its way, and the Russians were moving in. No anti-Communism, but a profoundly unpolitical attitude: free; light; *impolitely* nonideological.

And also the omnipresence of humor, of inconvenient humor. Which makes me think that people laugh at different things in every part of the world. How would anyone dispute Bertolt Brecht's sense of humor? Well, his theater adaptation

of *The Good Soldier Schweik* shows that he didn't understand a thing about Hašek's comical sense. Škvorecký's humor (like Hašek's or Hrabal's) is the humor of people who are far from power, make no claim to power, and see history as a blind old witch whose moral verdicts make them laugh. And I find it significant that it was precisely in that nonserious, antimoralist, anti-ideological spirit that, at the dawn of the 1960s, there began a great decade of Czech culture (in fact the last that could be called "great").

3

AH, THOSE BELOVED SIXTIES—AT THE TIME I LIKED TO SAY cynically: the ideal political regime is a *crumbling dictatorship*; the machinery of oppression functions ever more incompetently, but it is still in place to stimulate a critical, mocking turn of mind. In the summer of 1967, irritated by the bold congress of the Writers' Union, and feeling that the effrontery had gone quite far enough, the bosses of the State tried to harden their policies. But the critical spirit had already contaminated even the Party's Central Committee, which in January of 1968 decided to install an unknown fellow, one Alexander Dubček, as their chief. The Prague Spring began: gleeful, the country rejected the lifestyle imposed by Russia; the State borders opened up, and all the social organizations (the syndicates, unions, associations), initially meant to transmit to the people the Party's will, went independent and turned themselves into unexpected

instruments of an unexpected democracy. A system was born (with no advance planning, almost by chance) that was truly unprecedented: the economy 100 percent nationalized, agriculture in the hands of cooperatives, nobody too rich, nobody too poor, schools and medicine for free, but also: the end of the secret police's power, the end of political persecutions, the freedom to write without censorship, and consequently the blooming of literature, art, thought, journals. I cannot tell what the prospects might have been for the future of this system; in the geopolitical situation of the time, certainly not great; but in a different geopolitical situation? Who could know . . . Anyhow, for the second the system existed, the second was magnificent.

In his *Miracle in Bohemia* (completed in 1970), Škvorecký tells the story of that whole period between 1948 and 1968. The surprising thing is that he sets his skeptical gaze not only on the stupidity of the ruling power but also on the protesters, on the preening theatrics moving onto the Spring's scene. That was the reason the book was banned after the catastrophe of the Russian invasion—not only banned by the government, like all Škvorecký's books, but also disliked by the opposition, which, infected by the virus of moralism, could not bear the inconvenient freedom of its gaze, the inconvenient freedom of its irony.

4

WHEN, IN SEPTEMBER 1968 IN PARIS, THE ŠKVORECKÝS and I discussed our two separate Springs with our French

friends, we were not without worries: I was thinking about my difficult return to Prague, and they about their difficult emigration to Toronto. Josef's passion for American literature and for jazz had made their choice easy. (As if, since early childhood, we had each harbored an idea of the place for possible exile— I, France; they, North America.) But however great their cosmopolitanism, the Škvoreckýs were patriots. Oh, I know—these days, when the dance is being led by the Europe homogenizers, the word "patriot" carries some disdain. But excuse us: in those sinister times, how could we not be patriotic? In Toronto the Škvoreckýs lived in a little house with one room set aside for publishing the Czech writers banned in their own country. Nothing was more important than that. The Czech nation was born (several different times born) not because of its military conquests but because of its literature. And I don't mean literature as a political weapon. I mean literature as literature. In fact no political organization subsidized the Škvoreckýs; as publishers they could rely only on their own capacities and their own sacrifices. I will never forget it: I was living in Paris, and for me the heart of my native land was in Toronto. When the Russian occupation ended, there was no longer any reason to publish Czech books abroad. Since then, Zdena and Josef visit Prague from time to time, but they always return to their homeland to live.

To the homeland of their exile.

From Beneath You'll Breathe the Roses
(The Last Visit with Ernest Breleur)

WE WERE DRINKING WHITE RUM WITH BROWN SUGAR, as we always did; the canvases were on the floor, many canvases from the past several years. But that day I was concentrating on a few very recent paintings, leaning against the wall, which I was seeing for the first time and which differed from the previous works in the predominance of the color white. I asked, "Is that always death everywhere?" "Yes," he said.

In previous periods naked headless bodies soared, while down below small dogs wept in an endless night. Those nocturnal pictures I had thought were inspired by the past of slaves for whom night was the only time life was free. "So with your white paintings, has the night finally left?" "No. It's still night," he said. Then I understood: night had merely turned its shirt inside out. It was a night eternally set ablaze by the beyond.

He explained that in the early phase of the work, the canvas is highly colored, then gradually, white drippings like a curtain of fine threads, like rainfall, came to cover the painting. I said, "Angels visit your studio at night and piss white urine over your paintings."

One picture I stared at again and again: at the left an open door, in the middle a horizontal body floated as if it were coming out of a house. Below, at the right, a hat set down. I

understood: it was not the door of a house but the entrance to a tomb, the sort you see in Martinique cemeteries: little houses of white tile.

I looked at that hat at the bottom, so surprising at the edge of the tomb. Was it the incongruous presence of an object, in the Surrealist manner? The night before, I had gone to visit Hubert, another Martinican friend. He showed me a hat, the big beautiful hat of his long-dead father: "The hat, the memento that eldest boys here inherit from their fathers," he had explained.

And the roses. They floated around the gliding corpse or grew out of it. Suddenly some lines sprang into my head, verses I had marveled at when I was very young, the Czech verses of František Halas:

From below you'll breathe the roses
When you live your death
And in the night you'll throw off
Love your shield.

And I saw my native land, that land of Baroque churches, of Baroque cemeteries, of Baroque statues, with its obsession with death, its obsession with the departing body that no longer belongs to the living but that, even decomposed, goes on being a body, thus an object of love, of tenderness, of desire. And I saw before me the Africa of yesteryear and the Bohemia of yesteryear, a little village of Negroes and Pascal's infinite space, Surrealism and the Baroque, Halas and Césaire, urinating angels and weeping dogs, my own home and my elsewhere.

VII.

My First Love

The Long Race of a One-Legged Runner

IF I WERE ASKED WHAT FEATURE HAS INDELIBLY WRITTEN
my native land into my aesthetic genes, I would not hesitate to
answer: the music of Leos Janáček. Biographical coincidences
have some role in this: Janáček lived his whole life in Brno,
like my father who, as a young pianist, was a member of the
enchanted (and isolated) circle of the composer's connoisseurs
and defenders; I came into the world a year after Janáček had
left it and, from my earliest childhood, I would hear his music
played daily on the piano by my father or by his students; at
my father's funeral in 1971, during that somber period of the
Russian occupation, I forbade any orations; only at the crema-
torium, four musician friends played Janáček's Second String
Quartet.

Four years later I emigrated to France and, shaken by the
fate of my country, I talked about its greatest composer on
the radio, several times and at length. And later I happily ac-
cepted an invitation from a music journal to review recordings
of his music made during those years (the early nineties). It was
a pleasure, yes, but somewhat spoiled by the incredibly uneven
(and sometimes disgraceful) level of the performances. Of all
those recordings only two delighted me: the piano works played
by Alain Planès and the quartets played by the Berg Quartet of
Vienna. To pay them homage (and thereby to inveigh against

the others) I tried to define Janáček's style: "dizzyingly tight juxtaposition of highly contrasting themes that follow rapidly one upon another, without transitions and, often, resonating simultaneously; a tension between brutality and tenderness within an extremely short time span. And yet further: a tension between beauty and ugliness, for Janáček may be one of the rare composers who could pose in their music the problem familiar to great painters: ugliness as the subject of an artwork. (In his quartets, for instance, the passages played *sul ponticello* scrape and grate, and turn a musical sound into noise.)" But even this wonderful Berg Quartet recording came packaged with a text presenting Janáček in a stupidly nationalist light, calling him a "spiritual disciple of Smetana" (he was the opposite of that!) and reducing his expressivity to the romantic sentimentalism of a bygone time.

That different performances of the same music should have different qualities is quite natural. But with these Janáček disks it was a matter not of flawed rendition but of deafness to his aesthetic! Of a failure to comprehend his particularity! I find that incomprehension revealing, and significant, for it points to a curse that has weighed on the fate of his music. Thus this essay on "the long race of a one-legged runner":

Born in 1854 into a poor milieu, son of a village schoolteacher (in a small village), from age eleven on he lived in Brno, a provincial town on the margins of Czech intellectual life whose center was in Prague (which under the Austro-Hungarian monarchy was itself merely a provincial town). In such circumstances his artis-

tic development was unbelievably slow: he wrote music from a young age but did not discover his own style until he was nearly forty-five, as he composed *Jenůfa*, the opera he completed in 1902 and whose first performance took place in a modest Brno theater in 1904; he was fifty years old, and his hair was completely white. Constantly undervalued, nearly unknown, he was to wait through fourteen years of rejection until in 1916 *Jenůfa* was finally presented in Prague with unexpected success and, to general surprise, brought him immediate renown beyond the borders of his country. He was sixty-two, and the course of his life sped up at a dizzying rate; he had twelve years left to live and he wrote the major part of his work as if in an uninterrupted fever. Invited to all the festivals organized by the *International Society for Contemporary Music*, he appeared alongside Bartók, Schoenberg, Stravinsky as their brother (a much older brother, but nonetheless a brother).

So who was he? Some provincial character under the spell of folk music, as he was persistently described by the arrogant musicologists of Prague? Or one of the great figures of modern music? And in that case, of *which* modern music? He belonged to no recognized trend, no group, no school! He was different, and alone.

In 1919 the musicologist Vladimir Helfert became a professor at the Brno University and, fascinated by Janáček, immediately set about writing a huge monograph on him, planned for four volumes. Janáček died in 1928, and ten years later, after long labors, Helfert finished the first volume. It was 1938: Munich, the German occupation, the war. Deported to a concentration

camp, Helfert died in the first days after the war. Of his study we have only the first volume, ending with Janáček at just thirty-five years old, with no important work to his name yet.

An anecdote: In 1924 Max Brod had published an enthusiastic little monograph (in German) on Janáček, the first book about him to appear. Helfert promptly attacked it: Brod lacked any scholarly substance! The proof: there were some youthful Janáček compositions the fellow didn't even know existed! Janáček defended Brod: what was the point of considering unimportant work? Why judge a composer on music he himself does not value, and much of which he had even burned?

This is the archetypal conflict: a new style, a new aesthetic—how to grasp them? By running backwards to the artist's youth, his first coitus, his baby diapers, as historians like to do? Or, as the practitioners of an art do, by looking at the work itself, at its structure, analyzing and dissecting it, comparing and contrasting?

I think of the famous first performance of Victor Hugo's *Hernani*: the writer was twenty-eight years old, his supporters younger still, and they were all afire not only about the play but especially about its new aesthetic, which they knew well, which they advocated, which they did battle for. I think of Schoenberg: disliked as he was by a broad audience, still he was surrounded by young musicians, by his students and by connoisseurs, among them Adorno, who was to write a famous book about him, a major analysis of his music. I think of the Surrealists, forced to present their art accompanied by a theoretical manifesto so as

to head off any misinterpretation. In other words, all modern currents have had to fight *both* for their art *and* for their aesthetic program.

Back in his provincial home Janáček had no band of friends around him. No Adorno, not even a tenth, not a hundredth of an Adorno, was on hand to explain the novelty of his music, which therefore had to move ahead on its own, with no theoretical support, like a one-legged runner. In the last decade of his life, in Brno, a circle of young musicians adored him and understood him, but their voices were scarcely audible. A few months before his death, the Prague National Opera (the body that had rebuffed *Jenůfa* for fourteen years) produced Alban Berg's *Wozzeck*; the Prague audience, irritated by that too-modern music, whistled down the show, and the theater management, docilely and speedily, pulled *Wozzeck* from the repertory. The elderly Janáček took up Berg's defense, publicly and violently, as if he meant to make clear, while there was still time, whom he belonged with, who were his kin, the kinsmen whose presence he had been missing over a whole lifetime.

Today, eighty years after his death, I open up the Larousse dictionary and I read his portrait: "He undertook a systematic collection of folk music, whose juices fed all his work and all his political thinking" (just try to imagine the unlikely idiot such a line describes!). His work is "deeply national and ethnic" (which is to say, outside the international context of modern music!). His operas are "steeped in socialist ideology" (utter nonsense); his forms are described as "traditional" and his nonconformism

unremarked; of his operas the dictionary mentions *Sarka* (an immature work, justly forgotten) but offers not a word about *From the House of the Dead*, one of the greatest operas of the century.

So how can we be surprised that for decades, pianists and orchestra conductors, misled by all those wrongheaded signposts, should have erred in their search for his style? My admiration is all the greater for those who did understand it with immediate certainty: Charles Mackerras, Alain Planès, the Berg Quartet. . . . Seventy-five years after his death, in Paris in 2003, I attended a great concert, played twice over before an enthusiastic audience: Pierre Boulez conducting *Capriccio*, *Sinfonietta*, and *The Glagolitic Mass*. I never heard a Janáček that was more Janáčekian, with his bold clarity, his antiromantic expressivity, his brutal modernity. I said to myself then: Maybe, after a whole century of running, Janáček with his one leg is finally coming to join his own team, the team of his kinsmen, once and for all.

The Most Nostalgic Opera

1

Among Janáček's operas are five masterworks: the librettos of three of them (*Jenůfa*—1902, *Katya Kabanová*—1923, and *The Makropoulos Affair*—1924) are theater works adapted and shortened. The two others (*The Cunning Little Vixen*—1923, and *From the House of the Dead*—1927) are different: the one was based on a serial novel by a contemporary Czech author (a charming work but without great artistic ambition), the other inspired by Dostoyevsky's prison reminiscences. In these it was no longer enough to trim and arrange; it would be necessary to create autonomous theatrical works and construct a new architecture. A task that Janáček could not delegate, one that he took on himself.

A complicated task, further complicated by the fact that these two literary models lack dramatic composition and tension, *Vixen* being merely a suite of tableaux or scenes in a woodland *idyll*, and *House of the Dead* being a *reportage* on convicts' lives. And what's noteworthy: not only did Janáček do nothing in his adaptation to alleviate this absence of intrigue and suspense, he even emphasized it: he transformed this disadvantage into an asset.

The danger inherent in the art of opera is that the music can

easily become mere *illustration*; that the *spectator* concentrates so fully on the action of the story that he can cease to be a *listener*. From this standpoint Janáček's renunciation of story making, of dramatic action, seems the ultimate strategy of a master musician seeking to reverse the "balance of power" within the opera and place the music radically at the forefront.

This very suppression of plot is what allows Janáček, in these two works more than in the other three, to draw out *the specific nature of opera text*, which may be demonstrated by a negative proof: presented without the music, the librettos would look rather slight, slight because from the very start, Janáček assigned the dominant role to the music; it is the music that narrates, that reveals the characters' psychology, that excites feeling, that surprises, meditates, enthralls, and that even organizes the whole and determines its (actually very carefully wrought and polished) architecture.

2

THE PERSONIFIED ANIMALS COULD LEAD ONE TO SEE *THE Cunning Little Vixen* as a fairy tale, a fable, or an allegory; such an error would obscure the essential originality of this work, which is its grounding in the *prose* of human life, its ordinary dailiness. The setting: a woodland cottage, an inn, the forest; the characters: a woodsman with his two comrades, a village schoolteacher and a priest, then an innkeeper, his wife; a poacher; and the animals. Their personification does not tear

them out of the prose of daily life: the vixen is trapped by the woodsman, locked up in the yard, then she escapes, lives a life in the forest, bears her little foxes, is shot by a poacher and winds up as a muff for her killer's sweetheart. A playfully offhand smile in the animal scenes is all that's added to the routine of life as it is: a revolt by hens demanding social rights, some moralistic chatter among envious birds, and so on.

What links the animal world to the world of men is a common theme: the passage of time, old age as the end of every road. Old age: in his famous poem Michelangelo speaks of it as a painter would: amassing concrete, awful details of physical decline; Janáček speaks of it as a musician would: the "musical essence" of old age ("musical" in the sense of a state that music can get at, that music alone can express) is that bottomless nostalgia for time that is gone.

3

Nostalgia. It determines not only the climate of the work, but even its architecture, which is based on the parallelism of two kinds of time continually contrasted: the time of humans who age slowly, and the time of animals, whose lives speed along at a rapid pace; in the mirror of the fox's swift time the old woodsman senses the melancholy transience of his own life.

In the opera's first scene he wearily makes his way through the forest. "I feel exhausted," he sighs, "like after a wedding night"; he sits down and falls asleep. In the last scene, he again

recalls his wedding, and again he falls asleep beneath a tree. Thanks to that human framing, the vixen's own nuptial moment, with its joyous celebration in the middle of the opera, glows with the dappled light of endings.

The final passage of the opera begins with a scene that seems insignificant but that always grips my heart. The woodsman and the schoolteacher are alone at the inn. The third friend, the priest, has been transferred to a different village and is no longer with them. The innkeeper's wife is very busy and doesn't feel like talking. The teacher himself is taciturn: the woman he loves is to be married today. So the conversation is very sparse: where is the innkeeper? off to town; and how is the priest getting on? who knows; and the woodsman's dog, why isn't he here? he doesn't like to walk any longer, his paws hurt, he is old; "like us," the woodsman adds. I know no other opera scene so utterly banal in its dialogue; or any scene of sadness more poignant, more *real*.

Janáček has managed to say what *only an opera can say*: the unbearable nostalgia of insignificant talk at an inn cannot be expressed any other way than by an opera: the music becomes the fourth dimension of a situation which without it would remain anodyne, unnoticed, mute.

4

AFTER A GOOD DEAL OF DRINK THE TEACHER, ALONE OUT in the fields, sees a sunflower. Insane with love for a woman,

he believes it is she. He falls to his knees and declares his love to the sunflower: "Anywhere in the world, I'll go with you. I will hold you in my arms." Only seven measures of music, but great intensity of feeling. I quote them here with their harmonies, to show that there is not a single note which, through some unexpected dissonance (as would be the case with Stravinsky), would make a listener hear this declaration as grotesque:

This is the wisdom of Janáček the old man: he knows that the ludicrous element in our feelings does not make them any less authentic. The more profound and sincere the teacher's passion, the more comical it is, and the sadder. (To this point, imagine the sunflower scene without the music: it would be nothing *but* comical. Flatly comical. It is only the music that allows us to see the hidden pain.)

But let's look a bit longer at this love song to a sunflower. It lasts only seven measures, it doesn't repeat or return, it is

not protracted. This is the opposite of Wagnerian emotionalism, with its long melodies that deepen, broaden, and to the point of intoxication keep amplifying a single state of feeling. In Janáček the emotions are no less intense, but they are highly concentrated and thus brief. The world is like a carousel where feelings spin past, revolve, give way to others, clash, and despite their incompatibility, may often sound at once, which makes for an inimitable tension in all Janáčekian music; witness the very first measures of *The Cunning Little Vixen*: a languidly nostalgic *legato* motif collides with a disturbing *staccato* motif, which ends in three quick notes repeated several times and gradually more and more aggressive:

These two emotionally contradictory motifs, set out at the same time, intermingled, superimposed, the one against the other, take up the first forty-one bars with their disquieting simultaneity and immediately plunge us into the tense emotional climate of the heartbreaking idyll that is *The Cunning Little Vixen*.

5

LAST ACT: THE WOODSMAN BIDS THE TEACHER GOOD-BYE and leaves the inn; in the forest he lets nostalgia overtake him: he recalls the day of his marriage, when he strolled with his wife beneath these same trees: an enthralling melody, the exaltation of a long-gone springtime. So then, does this turn into a conventional sentimental finale after all? Not completely "conventional," for the prosaic keeps interrupting, invading the exaltation; first with an unpleasant buzz of flies (violins played *sul ponticello*); the woodsman swats them away from his face: "If it weren't for these flies, I'd fall asleep right away." For, don't forget, he is old, old as his dog with the painful feet; yet over another several measures he continues his song before actually dozing off. In his dream he sees all the woodland creatures, among them a baby fox, the daughter of the cunning vixen. He tells her: "I'm going to trap you like your mama, but this time I'll take better care of you, so they don't write about you and me in the newspapers." This is an allusion to the serial story out of which Janáček had built his opera; a joke that wakes us (but only for a few seconds) from the very intensely

lyrical atmosphere. Then a frog comes by: "You little monster, what are you doing here?" asks the woodsman. The frog stammers a reply: "The fuh-frog you think you-you're s-s-seeing isn't me, it's my-my grandfather. He t-told me a lot ab-about you." And these are the last words of the opera. The woodsman sleeps deeply beneath a tree (perhaps he snores a bit) as the music (briefly, only a few measures) swells in a drunken ecstasy.

6

AH, THAT LITTLE FROG! MAX BROD DID NOT LIKE HIM at all. Max Brod—yes, Franz Kafka's closest friend—he supported Janáček wherever and however he could: he translated his operas into German and opened German theaters to them. The sincerity of his friendship authorized him to let the composer know all his criticisms. The frog must go, he wrote Janáček in a letter, and in place of his stammering, the woodsman should solemnly pronounce the words that will close the opera! And he even suggests what they should be: "*So kehrt alles zurück, alles in ewiger Jugendpracht!* (Thus do all things repeat, all with a timeless youthful power.)"

Janáček refused. Brod's proposal went against all his aesthetic intentions, against the polemic he had waged his whole life long. A polemic that set him in opposition to opera tradition. In opposition to Wagner. In opposition to Smetana. In opposition to the official musicology of his countrymen. In

other words, in opposition (to quote René Girard) to "the romantic lie." The little disagreement about the frog shows Brod's incurable romanticism: imagine that weary old woodsman, his arms widespread, head thrown back, singing the glory of eternal youth! This is the romantic lie par excellence, or, to use another term: this is *kitsch*.

The greatest literary figures of Central Europe in the twentieth century (Kafka, Musil, Broch, Gombrowicz, but Freud as well) rebelled (they were very much alone in that rebellion) against the legacy of the preceding century, which in their part of Europe bowed under the particularly heavy weight of Romanticism. They felt that in its vulgar paroxysm, Romanticism inevitably ends in kitsch. And kitsch was, for them (and for their disciples and heirs), the greatest *aesthetic evil*.

Central Europe, in the nineteenth century, gave the world no Balzac, no Stendhal, but it did worship opera, which played a social, political, and national role there as it did nowhere else. And so it is *opera as such*, its spirit, its proverbial grandiloquence, that stirred the ironical irritation of those great modernists; to Hermann Broch, for instance, Wagner's opera, with its pomp and sentimentality, its unrealism, represented the very paradigm of kitsch.

In the aesthetic of his work Janáček was part of that constellation of great (and solitary) anti-Romantics of Central Europe. Although he had devoted his whole life to opera, his position on its *tradition*, its *conventions*, its *gesticulation*, was as critical as Hermann Broch's.

7

JANÁČEK WAS ONE OF THE FIRST TO COMPOSE AN OPERA
(he began *Jenůfa* before the end of the nineteenth century) on
a *prose* text. It was as if this great gesture, by which he rejected
versified language once and for all (and with it, a poeticized
vision of reality), as if this great gesture had suddenly led him
to discover his entire style. And his great wager, too: seeking
musical beauty in prose: in the prose of ordinary situations; in
the prose of the *spoken language* that would inspire the original-
ity of his melodic art.

Elegiac nostalgia: the sublime, eternal subject of music and
of poetry. But the nostalgia that Janáček unveils in *The Cunning
Little Vixen* is a far cry from theatrical gestures bemoaning
times gone by. This nostalgia is terribly real, it is to be found
where no one looks for it: in the quiet talk of two old men at an
inn; in the death of a poor animal; in the love of a schoolteacher
on his knees before a sunflower.

VIII.

Forgetting Schoenberg

No Celebration
(a text published in 1995 in the Frankfurter Rundschau
*together with other pieces celebrating the hundredth
anniversary of the birth of cinema)*

WHAT THE BROTHERS LUMIÈRE INVENTED IN 1895 WAS
not an art but a technology that made it possible to capture, to
display, to keep, and to archive the visual image of a reality, not
in a fraction of a second but in its movement and its duration.
Without that discovery of the "moving photo," the world today
would not be what it is: the new technology has become, primo,
the principal agent of stupidity (incomparably more powerful
than the bad literature of old: advertisements, television series);
and secundo, *the agent of worldwide indiscretion* (cameras se-
cretly filming political adversaries in compromising situations,
immortalizing the pain of a half-naked woman laid out on a
stretcher after a street bombing).

It is true that *film as art* does also exist, but its significance
is far more limited than that of film as technology, and its his-
tory is certainly shorter than that of any other art. I remember
a dinner in Paris more than twenty years ago: a pleasant, in-
telligent young man is talking about Fellini with an amused,
mocking scorn. He finds the latest film frankly dreadful. I
watch him as if hypnotized. Knowing the cost of imagination,
I feel above all a humble admiration for Fellini's films. In the

presence of this clever young fellow, in the France of the early 1980s, I experienced for the first time a sensation I never felt in Czechoslovakia, even in the worst Stalinist years: the sense that we have come to the era of post-art, in a world where art is dying because the need for art, the sensitivity and the love for it, is dying.

Since then I have more and more often seen that Fellini was no longer beloved; even though the man's work had created a whole great epoch in the history of modern art (like Stravinsky, like Picasso); even though with his incomparable imagination he had achieved the fusion of dream and reality, that old project-wish of the Surrealists; even though in his late period (particularly underrated), he had managed to bring to his own dreamy gaze a clear-eyed lucidity that cruelly unmasks our contemporary world (remember *Orchestra Rehearsal*, *City of Women*, *And the Ship Sails On*, *Ginger and Fred*, *Interview*, *The Voice of the Moon*).

During that late period Fellini violently attacked the media magnate Silvio Berlusconi, protesting against his practice of allowing televised films to be interrupted by advertising. I found that confrontation deeply significant: since the advertising spot is also a genre of cinematography, this was a confrontation between two different legacies from the brothers Lumière: between film as art and film as agent of stupidity. We know the outcome: film as art has lost.

That confrontation had its epilogue in 1993 when Berlusconi's television screens showed Fellini's body, naked, defenseless,

in the throes of death (a strange coincidence: in an unforget-
table, and prophetic, scene in Fellini's 1960 film *La Dolce Vita*,
the camera's necrophiliac frenzy was captured and displayed
for the first time). The historical turning point was complete:
as heirs of the brothers Lumière, Fellini's orphans no longer
counted for much. Fellini's Europe was set aside by a wholly
other Europe. A hundred years of cinema? Yes. But I'm not
celebrating.

What Will Be Left of You, Bertolt?

IN APRIL 1999 A PARIS WEEKLY (ONE OF THE MORE SERIOUS ones) published a special section on *Geniuses of the Century*. There were eighteen on the list of honorees: Coco Chanel, Maria Callas, Sigmund Freud, Marie Curie, Yves Saint Laurent, Le Corbusier, Alexander Fleming, Robert Oppenheimer, Rockefeller, Stanley Kubrick, Bill Gates, Pablo Picasso, Henry Ford, Albert Einstein, Robert Noyes, Edward Teller, Thomas Edison, J. P. Morgan. So, then: no novelist, no poet, no dramatist; no philosopher; a single architect; a single painter, but two couturiers; no composer, one singer; a single moviemaker (over Eisenstein, Chaplin, Bergman, Fellini, the Paris journalists chose Kubrick). This honor roll was not something put together by ignorant people. With great lucidity it declared a real change: the new relationship of Europe to literature, to philosophy, to art.

Have the great cultural figures been forgotten? "Forgotten" is not the right word. I remember that at that same period, toward the end of the century, we were inundated by a tidal wave of monographs: on Graham Greene, on Ernest Hemingway, on T. S. Eliot, on Philip Larkin, on Bertolt Brecht, on Martin Heidegger, on Pablo Picasso, on Eugène Ionesco, on Cioran, and endless others.

These venomous works (my gratitude to Craig Raine for defending Eliot, to Martin Amis who took up for Larkin) made

clear the meaning of that honors list: the geniuses of culture have been set aside without regret; it is comforting to prefer Coco Chanel and the innocence of her dresses over those great cultural figures, all of them tainted with the century's ills, its perversity, its crimes. Europe was moving into the *age of the prosecutors*: Europe was no longer loved, Europe no longer loved itself.

Does that mean that all those monographs were especially harsh toward the works of the writers portrayed? Oh no; at that time art had already lost its appeal, and the professors and connoisseurs were no longer interested in either paintings or books, only in the people who had made them; in their lives.

In the age of the prosecutors what does a life mean?

A long succession of events whose deceptive surface is meant to hide Sin.

To ferret out Sin beneath its disguise, the monographer must have a detective's talent and a network of informers. And so as not to sacrifice his lofty stature as expert, he must cite the names of his informers in footnotes, for in the eyes of scholarship this turns gossip into truth.

I open a huge eight-hundred-page book on Bertolt Brecht. The author, a professor of comparative literature, after demonstrating in detail the vileness of Brecht's *soul* (secret homosexuality, erotomania, exploitation of girlfriends who were the true authors of his plays, pro-Stalin sympathies, tendency to lies, greed, a cold heart), finally in chapter 45 comes to his *body*, in particular to its terrible odor, which the professor takes a whole paragraph to describe. As guarantee of the scholarly nature of this olfactory revelation, in a note to the chapter the writer says

he collected "this detailed description from the woman who was at the time the head of the photo lab of the Berliner Ensemble, Vera Tenschert," whom he interviewed "on June 5, 1985" (that is, thirty years after the smelly fellow was laid in his coffin).

Ah, Bertolt, what will be left of you?

Your body odor, preserved for thirty years by your faithful colleague and then revived by a scholar who, after intensifying it by the modern methods of university laboratories, has now sent it forth into the future of our millennium.

Forgetting Schoenberg

A YEAR OR TWO AFTER THE WAR, AS AN ADOLESCENT, I MET a young Jewish couple some five years older than I. They had spent their youth in the Terezín concentration camp and later in another camp. I felt intimidated by their fate; it was beyond me. My awe irritated them: "Stop that! Just stop it!" and they insisted I see that life there had retained its full range, with jokes as well as tears, tenderness as well as horror. For love of their own lives, they refused to be transformed into legends, into statues of misfortune, into a file in the black book of Nazism. I've completely lost track of them since, but I have never forgotten what they urged me to understand.

Terezín, in Czech; Theresienstadt, in German. A city turned into a ghetto that the Nazis used as a showcase, where they allowed their prisoners to live a relatively civilized life in order to show them off to the pushovers from the International Red Cross. The place collected Jews from Central Europe, mostly from its Austro-Czech regions; among them were many intellectuals, composers, writers, of the great generation who had lived in the glow of Freud, Mahler, Janáček, Schoenberg's Viennese school, the Prague structuralists.

They were under no illusions: they were living in death's antechamber; their cultural life was on exhibit by Nazi propaganda as an alibi; but should that be a reason to refuse freedom,

however precarious and fraudulent? Their response was utterly clear: their creations, their art shows, their concerts, their loves, the whole array of their lives were incomparably more important than their jailers' macabre theatrics. That was their wager. Their intellectual and artistic activity leaves us dumbstruck: not only at the work they managed to produce (I think of the composers! Pavel Haas, Janáček's pupil, who taught me composition when I was a child! And Hans Krasa! And Gideon Klein! And Karel Ančerl, who after the war became one of the greatest conductors in Europe!) but perhaps even more, at the thirst for culture that, in those dreadful conditions, gripped the whole Terezín community.

What did art mean to them? It was the way to keep fully deployed the whole range of feeling and thought so that life should not be reduced to the single dimension of horror. And for the artists held there? They saw their personal destinies fused with the fate of modern art, the art called "degenerate," the art that was hunted down, mocked, condemned to death. I have before me the poster for a concert in the Terezín of the time: Mahler, Zemlinsky, Schoenberg, Haba. Under the executioners' watch the condemned played condemned music.

I think of the last years of this past century. Memory, the duty of memory, the work of memory, were the banner words of that time. It was considered an act of honor to hunt out past political crimes, right down to their very shadows, down to their last vile stains. And yet that very particular sort of memory, incriminating memory, the diligent handmaiden of punishment, had nothing in common with the sort of memory so passion-

ately important to the Jews at Terezín, who cared not a damn about immortalizing their torturers and instead did all they could to preserve the memory of Mahler and Schoenberg.

Once, as I was discussing this topic with a friend, I asked him: "Do you know 'A Warsaw Survivor'?" "A survivor? Who? What survivor?" He didn't know what I was talking about. And yet *A Warsaw Survivor* (*Ein Überlebender aus Warschau*), an oratorio by Arnold Schoenberg, is the greatest monument music ever dedicated to the Holocaust. The whole existential essence of the drama of the Jews in the twentieth century is kept alive in it. In all its fearsome grandeur. In all its fearsome beauty. People fight to ensure that the murderers should not be forgotten. But Schoenberg they forget.

IX.

THE SKIN:
MALAPARTE'S ARCH-NOVEL

1. Seeking a Form

THERE ARE WRITERS, GREAT WRITERS, WHO DAZZLE US with the power of their minds, but who are marked with a kind of curse: for what they have to say they never found an original form that is linked to their personality as inseparably as are their ideas. I think for instance of the great French writers born around the start of the twentieth century; in my youth I adored them all; Sartre perhaps most. A curious thing: in his essays (his "manifestos") on literature he surprised me with his mistrust for the notion of the novel; he dislikes the terms "novel," "novelist"; this word that is the prime indicator of a form, he avoids using; he only speaks of "prose," the "prose writer," sometimes the "prosateur." He explains: he'll acknowledge an "aesthetic autonomy" for poetry, but not for prose: "Prose is in essence utilitarian . . . the writer is a *speaker*: he designates, demonstrates, orders, rejects, questions, entreats, insults, persuades, insinuates." But in that case, how does the form matter? He replies: "It is a question of intent, of knowing what you mean to write about: about butterflies or about the Jewish condition. And once you know that, you decide how to write about it." And, in fact, all Sartre's novels, important as they may be, are characterized by the *eclecticism* of their form.

Hearing the name Tolstoy, I instantly think of his two great novels, which are like nothing else. When I say Sartre, Camus,

Malraux, it is not their novels that come first to my mind but their biographies, their polemics and battles, their positions.

2. The Forerunner of "the Engaged Writer"

THE ITALIAN CURZIO MALAPARTE, TO WHOM I DEVOTE THE last part of this book, belonged to Sartre's generation. In the Sartrian sense, but some twenty years earlier, he was already an "engaged," or committed, writer. Rather, we should say, an early example of the phenomenon, for that famous Sartre term was not yet in use, and Malaparte had not yet written anything. At fifteen he was secretary of the local youth section of the Italian republican (leftist) party; when he was sixteen the 1914 war broke out; he left his home, crossed the French border, and enlisted in a legion of volunteers to fight the Germans.

I don't mean to impute any greater importance to an adolescent's decisions than they are due; but still, Malaparte's behavior was remarkable. And sincere: carried out, need we note, far from the media hoopla which these days would inevitably attend any political act. Toward the end of the war, during a fierce battle, he was gravely wounded by German flamethrowers. His lungs would remain forever damaged from the attack, and his soul traumatized.

But why did I say that this student-soldier was an advance model of the engaged *writer*? Later he would recount a memory: the young Italian volunteers soon split into two rival groups: one

side claimed inspiration from the great soldier Garibaldi, the other from Petrarch, the great poet (who six hundred years earlier had lived in this part of southern France where the volunteers were mustering before leaving for the front). In that dispute among adolescents, Malaparte lined up under the Petrarch flag against the Garibaldians. His commitment, from the start, was not that of a syndicalist, a political activist, but rather that of a Shelley, a Hugo, or a Malraux.

After the war, as a young (very young) man, he joins Mussolini's party; still affected by the memory of the massacres, he sees in Fascism the promise of a revolution that would sweep away the world as he has known and detested it. He is a journalist, aware of everything going on in the world of politics; he is worldly, scintillating, and seductive, but he is mainly a lover of art and poetry. He still prefers Petrarch to Garibaldi, and the people he cherishes above all are artists and writers.

And because Petrarch means more to him than Garibaldi, his political engagement is personal, extravagant, independent, undisciplined, so that he soon finds himself in conflict with the ruling powers (in Russia, at that same moment, the Communist intellectuals were in a similar situation); he is even arrested "for anti-Fascist activities," expelled from the Party, imprisoned for a while, then sentenced to a long house arrest. Eventually released, he returns to journalism. Mobilized in 1940, and attached to the Axis armies, he sends home articles from the Russian front that are soon (correctly) seen as anti-German and anti-Fascist, and he spends another several months in prison.

3. Finding a Form

THROUGHOUT HIS LIFE, MALAPARTE WROTE A GOOD many books—essays, polemics, observations, memoirs—all intelligent, brilliant, but all of which would certainly be already forgotten if *Kaputt* and *The Skin* did not exist. With *Kaputt* he not only wrote an important book, but he invented a form that is a totally new thing and that belongs to him alone.

What is this book? At first glance it looks to be reportage by a war correspondent. An exceptional, even sensational, reportage, because as a journalist for *Corriere della Sera* and an officer of the Italian army, he moves through Nazi-occupied Europe with the freedom of an undetectable spy. The political world opens up to him, this brilliant habitué of the salons: in *Kaputt*, he describes his conversations with Italian statesmen (in particular with Ciano, the foreign minister and Mussolini's son-in-law), with German politicians (with Frank, the governor-general of Poland, who is organizing massacres of Jews, but also with Himmler, whom he runs across naked in a Finnish sauna), with the dictators of the satellite countries (for instance, Ante Pavelić, the boss of Croatia), his urbane social relations accompanied by observations on the real life of ordinary folk (in Germany, Ukraine, Serbia, Croatia, Poland, Romania, Finland).

Given the unique nature of Malaparte's accounts, it is astonishing that no historian of World War II has cited his experiences or quoted the remarks of the politicians whom he let talk

at length in his book. It is strange, yes, but understandable: for this reportage is something other than reportage; it is a *literary work* whose *aesthetic intention* is so strong, so apparent, that the sensitive reader *automatically* excludes it from the context of accounts brought to bear by historians, journalists, political analysts, memoirists.

The aesthetic intention of the book shows most strikingly in its originality of form. To try to describe its architecture: it is *triply* divided: into parts, chapters, and sections. There are six parts (each titled); each part has several chapters (also titled); and each chapter is divided into sections (which are without titles, separated each from the next by only a blank line).

These are the titles of the six parts: "Horses," "Rats," "Dogs," "Birds," "Reindeer," "Flies." These animals are present both as material creatures (the unforgettable scene from the first part: a hundred horses trapped in a frozen lake, with only their dead heads jutting above the ice) but also (and especially) as metaphors (in the second part the rats symbolizing Jews as the Germans called them; or, in the sixth part, the flies actually proliferating from the heat and the corpses but also symbolizing the atmosphere of the war that will not end).

The unfolding of events is not organized as a *chronological* succession of the reporter's experiences; intentionally *heterogeneous*, the events of each part are set in several historical moments, in various places; for instance, the first part (Malaparte is in Stockholm at an old friend's house) comprises three chapters: in the first the two men recall their past life in Paris; in the second Malaparte (still in Stockholm with his friend)

describes his experiences in the Ukraine blood-drenched by the war; in the third and last chapter he describes his time in Finland (which is where he saw the hideous spectacle of the horses' heads jutting through the surface of a frozen lake). Thus the events of each part occur neither at the same date nor at the same place; but the part is unified by a common atmosphere, a common group fate (for example, in the second part, the fate of the Jews), and above all a common aspect of human existence (indicated by the animal metaphor of the part's title).

4. The Disengaged Writer

THE MANUSCRIPT OF *KAPUTT*, WRITTEN IN EXTRAORDINARY circumstances (much of it in the home of a peasant in Ukraine under Wehrmacht occupation), was published in 1944, even before the end of the war, in an Italy just barely liberated. *The Skin*, written immediately afterward, during the first postwar years, was published in 1949. The two books are alike: the form Malaparte invented in *Kaputt* also underlies *The Skin*; but however clear the kinship between the two books, more important is their difference:

On *Kaputt*'s stage there very often appear actual historical figures, which makes for some ambiguity: how are these passages to be understood? as the account of a journalist proud of the precision and the honesty of his testimony? or as the fantasy of an author concerned to put across his own vision of these historical figures, with the full freedom of a poet?

In *The Skin* the ambiguity is gone: here no historical figures appear. There are still the great fashionable gatherings, where the Italian aristocrats of Naples hobnob with American army officers, but whether the names they bear are real or invented is unimportant. The American colonel Jack Hamilton who accompanies Malaparte throughout the whole book: did he actually exist? If he did, was his name Jack Hamilton? And did he say what Malaparte has him saying? These questions are of absolutely no interest whatever. For we have *entirely* quit the territory of journalists or memoirists.

Another big difference: the man who wrote *Kaputt* was an "engaged writer," that is to say, confident that he knew where to assign good and evil. He detested the German invaders as he had detested them when he was eighteen years old, with flame-throwers in their hands. How could he have felt neutral after seeing the pogroms? (About Jews: who else has written so shattering an account of their daily persecution in all the occupied countries? And in 1944 at that, when no one was yet talking much about the subject and people scarcely even knew anything about it!)

In *The Skin* the war is not yet over, but its conclusion is already decided. The bombs are still falling, but falling now on a different Europe. Yesterday no one had to ask who was the executioner and who the victim. Now, suddenly, good and evil have veiled their faces; the new world is still barely known; unknown; enigmatic; the person telling the tale is sure of only one thing: he is certain he can be certain of nothing. His ignorance becomes wisdom. In *Kaputt* during those drawing-room chats

with Fascists or collaborators, Malaparte deployed a constant chill irony to mask his own thoughts, which were thus all the clearer to his readers. In *The Skin* his speech is neither chill nor clear. It is still ironical, but the irony is desperate, often overwrought; he exaggerates, he contradicts himself; with his words he does himself harm and he harms others; it is a doleful man speaking. Not an "engaged" writer. A poet.

5. *Composing* The Skin

AS DIFFERENT FROM THE *TRIPLE* DIVISION OF *KAPUTT* (into parts, chapters, sections), the division of *The Skin* is only a *double* one: there are no parts, only the sequence of twelve chapters, each with its own title and made up of several untitled sections separated from one another by a blank line. Thus the composition is simpler, the narration swifter, and the whole book a quarter shorter than the preceding one. As if the slightly plump body of *Kaputt* had undergone a slenderizing regimen.

And a beautifying one. I'll try to illustrate this beauty with chapter 6 ("The Black Wind"), an especially fascinating one, which contains five sections:

The first, superbly short, consists of a single paragraph of four sentences and develops a single oneiric image of the "black wind" that, "like a blind person tentatively feeling his way," moves through the world, a messenger of misfortune.

The second section describes a recollection: in war-torn

Ukraine, two years before the book's present time, Malaparte is riding his horse along a road lined on either side with a row of trees, where Jews are nailed up and hang crucified, waiting to die. Malaparte hears their voices asking him to kill them, to cut short their suffering.

The third section also recounts a recollection; this one goes back yet further into the past, to Lipari, the island where before the war Malaparte had been deported: it is the story of his dog Febo. "Never have I loved a woman, a brother, a friend as I loved Febo." The dog was with him over the two last years of his island detention, and it went with him to the mainland upon his release.

The fourth section continues the story of Febo, who disappears one day. After arduous searching, Malaparte learns that the animal was snatched by a hoodlum and sold to a hospital for medical research. He finds him there, "stretched out on his back, his belly open, a probe buried in his liver." No moans come from his mouth because, before operating, the doctors routinely cut the vocal cords in all the dogs. Out of sympathy for Malaparte, the doctor gives Febo a fatal injection.

The fifth section returns to the present time of the book: Malaparte's accompanying the American army as it advances on Rome. A soldier is hideously wounded, his belly torn open, his intestines coiling out onto his thighs. His sergeant insists that the boy be transported to a hospital. Malaparte protests violently: the hospital is very far off, the jeep journey would be long and would cause the soldier terrible suffering; he should

be kept where he is and allowed to die without knowing he is dying. In the end the soldier does die, and the sergeant punches Malaparte full in the face: "It's your fault he died, died like a dog!" The doctor who comes to register the death shakes Malaparte's hand: "I thank you in his mother's name."

Even though each of these five sections is set in a different time, a different place, they are all perfectly linked together. The first section develops the metaphor of a *black wind*, an atmosphere that will cover the whole chapter. In the second section that wind moves through the Ukrainian landscape. In the third, on the island of Lipari, the wind is always present, as an obsession with death "always prowling around men invisibly, taciturn and suspicious." For death is everywhere in this chapter. Death, and man's attitude toward it, an attitude at once cowardly, hypocritical, ignorant, powerless, awkward, helpless. The Jews crucified to the trees moan. Febo lies mute on the dissection table because his vocal cords have been cut. Malaparte teeters at the brink of madness, incapable of killing the Jews to end their suffering. He does find the courage to give Febo his death. The theme of euthanasia reappears in the last section of the chapter, where Malaparte refuses to prolong the misery of a mortally wounded soldier, and the sergeant punishes him with a punch.

This whole chapter, so heterogeneous, is marvelously unified by the consistent atmosphere, the same themes (death, the animal, euthanasia), the repetition of the same metaphors and the same words (out of which comes a melody that transports us with its inexhaustible breath).

6. The Skin *and Modernity in the Novel*

IN HIS PREFACE TO THE FRENCH EDITION OF A VOLUME of Malaparte essays, the author calls *Kaputt* and *The Skin* "major novels by this *enfant terrible*." Novels? Are they, actually? Yes, I do agree. Even though I know that the form of *The Skin* is unlike what most readers consider to be a novel. Such a case is actually far from unusual: there are many great novels that, at their birth, are unlike the commonly held idea of the novel. And so? Isn't a great novel great precisely because it does not repeat what already existed? The great novelists themselves have often been surprised by the odd form of the thing they've written, and they would rather avoid useless arguments over the genre of their book. Still, in the case of *The Skin* the difference is radical, depending on whether the reader approaches it as a piece of journalism that will broaden his knowledge of history, or as a literary work that will enrich him with its beauty and its understanding of mankind.

And then this: it is difficult to grasp the value (the originality, the newness, the charm) of a work of art without seeing it in the context of that particular art's history. And I find it significant that everything about *The Skin*'s form that seems to contradict the very idea of the novel should also reflect the new climate in the aesthetic of the novel as it took shape in the twentieth century, in contrast to its norms in the century before. For instance: all the great modern novelists had a somewhat distant relation to story in a novel, no longer

considering it to be the indispensable basis for ensuring unity in a work.

So the striking feature of *The Skin*'s form is that the composition does not rely on a story, on any causal sequence of actions. The *present time* of the novel is shaped by its "starting point" (in October 1943 the American army enters Naples) and its "end point" (in the summer of 1944 Jimmy bids Malaparte farewell before his final departure for the States). Between those two dividers the Allied army marches from Naples to the Apennine mountains. Everything that occurs within that span of time is marked by an extraordinary *heterogeneity* (of places, of times, of situations, of memories, of characters); and I emphasize this: that heterogeneity, new in the history of the novel, in no way weakens the unity of the composition; the same breath blows through each of the twelve chapters, forming them into a single universe with the same atmosphere, the same themes, the same characters, the same images, the same metaphors, the same refrains.

The same decor: *Naples*: the place where the book starts and where it ends and the place whose memory remains omnipresent; the *moon*: it shines above all the landscapes of the book: in Ukraine it illuminates the crucified Jews nailed to the trees; hanging over settlements of wandering tramps, "as a rose does, it perfumes the sky like a garden"; "ecstatic and wondrously distant," it lights the mountains of Tivoli; "enormous, dripping blood," it gazes upon a battlefield covered with bodies. Words made into refrains: *the plague*: it appears in Naples on the same day as the American army, as if the liberators had brought it along as a gift to the liberated; later on it becomes a metaphor for

the massive denunciations spreading like the worst pandemic; or, at the very start, the *flag*: on orders from their king, the Italians flung it "heroically" into the mud, then raised it up as their new flag, and then again threw it down and again raised it up, with huge blasphemous laughter, and toward the end of the book, as if in answer to that early scene, a human body is crushed by a tank, flattened and brandished "like a flag."

I could go on quoting ad infinitum the words, the metaphors, the themes that return as repetitions, variations, responses, and thereby create the novel's unity, but I pause over a further charm of this composition, which purposely abstains from story: Jack Hamilton dies, and Malaparte knows that from now on, in the midst of his own people, in his own country, he will forever feel alone. And yet Jack's death is indicated (no more than indicated, we never even learn how or where he dies) by a single phrase in a long paragraph that talks about other things as well. In any novel built on a story line, the death of such an important character would be described at length, and would probably constitute the conclusion of the book. But, curiously, because of that very brevity, that reticence, that delicacy, because of the absence of any description at all, Jack's death becomes unbearably moving.

7. *The Retreat of Psychology*

WHEN A FAIRLY STABLE SOCIETY MOVES ALONG AT A fairly slow pace, a man may seek to distinguish himself from

his fellows (who so sadly seem all alike), by paying great attention to his own small psychological particularities, the only thing that affords him the pleasure of relishing his singularity, which he hopes is inimitable. But the 1914 war, that gigantic absurd massacre, set Europe off on a new epoch in which history, imperative and avid, rears up before a man and seizes hold of him. Henceforth men will be shaped primarily *from the outside*. And I emphasize: these jolts from the exterior will be no less surprising, no less puzzling, no less difficult to understand, with all their consequences for men's ways of acting and reacting, than the secret wounds hidden deep in the unconscious; and no less fascinating for a novelist. In fact, only a novelist will be capable of grasping, like no one else, this shift that the times have brought to human existence. And for that reason it is self-evident that the novelist will have to ring some changes in the current form of the novel.

The characters in *The Skin* are perfectly real, and yet never individualized by biographical accounts. What do we know about Jack Hamilton, Malaparte's best friend? That he taught in an American university, he has a loving familiarity with European culture, and at present feels disconcerted by a Europe he cannot recognize. That's all. No information about his family, his private life. None of what a nineteenth-century novelist would consider indispensable for making a character real and "alive." One could say the same about all the characters in *The Skin* (including Malaparte as a character—there is not a single word about his personal, private past).

The withdrawal from psychology: Kafka proclaimed this

in his notebooks. In fact, what do we learn of K.'s psychological roots, about his childhood, his parents, his loves? As little as we do about Jack Hamilton's intimate history.

8. Raving Beauty

IN THE NINETEENTH CENTURY, IT WAS TAKEN FOR GRANTED: whatever happened in a novel had to be plausible. In the twentieth century, this rule lost its force; from Kafka to Carpentier or García Márquez, novelists grew increasingly sensitive to the *poetry of the improbable*. Malaparte (who was not an admirer of Kafka and did not know either Carpentier or García Márquez) succumbed to that same temptation.

Once again I recall the scene where, early one night, Malaparte is moving on horseback beneath a double file of trees; he hears voices above his head and as the moon rises he realizes that these are crucified Jews. . . . Is this true? Is it fantasy? Fantasy or not, it is unforgettable. And I think of Alejo Carpentier who, in Paris in the 1920s, shared the Surrealists' passion for delirious imagination, joined their conquest of the "marvelous," but who twenty years later in Caracas was seized with doubts: what used to enchant him he now saw as mere "poetic routine," like a "conjuror's trick"; he distanced himself from Parisian Surrealism not to return to the old realism but because he thought he had found a different "marvelous," a truer one, grounded in *reality*, the reality of Latin America where everything looked improbable. I imagine that Malaparte experienced something

similar; he too had loved the Surrealists (in the journal he founded in 1937 he published his translations of Éluard and Aragon), which did not cause him to follow them but may have made him more sensitive to the somber beauty of reality gone raving mad, full of strange encounters "between an umbrella and a sewing machine."

In fact such an encounter opens *The Skin*: "The plague broke out in Naples on the first of October 1943, the very day when the Allied armies entered that unhappy city as liberators." And toward the end of the book, in the ninth chapter, "The Firestorm," a similar surreal encounter takes on the proportions of a widespread delirium: all through Holy Week the Germans bombard Naples, a young girl is killed and laid out on a table in a castle, and *at the same time*, with a dreadful racket, Vesuvius starts to spit out lava as it had "never done since the day when Herculaneum and Pompei were shrouded alive in their tomb of ashes." The volcanic eruption sets off madness in men and nature both: clouds of small birds take refuge in the tabernacles around the statuettes of saints, women force open the bordello doors and drag out the naked whores by their hair, the roads are strewn with dead bodies, their faces encased in a shell of white ash, "as if they had an egg instead of a head," and nature never stops rampaging. . . .

In another passage of the book, the improbable is more grotesque than it is horrible: the sea around Naples is riddled with mines that make fishing impossible. To provide for a banquet the American generals must go gather the dinner fish from the famous aquarium. But when General Cork plans a dinner in

honor of Mrs. Flat, an important political envoy from America, there is only one fish left in the Naples aquarium: the Siren, "a very rare example of the species of 'sirenoids' which, because of their nearly human form, gave rise to the ancient legend of the Sirens." When the fish platter is set out on the table, there is consternation. "I hope you won't force me to eat that . . . that poor girl!" cries Mrs. Flat, aghast. Embarrassed, the general orders "that horrible thing" taken away, but that does not satisfy Colonel Brown, the army chaplain: he orders the servants to take the fish away in a silver coffin carried on a stretcher, and he goes along with them to guarantee a Christian burial.

In Ukraine, in 1941, a Jew was crushed by the tracks of a tank; he became "a carpet made of human skin"; some Jews start to peel it out of the dust; then "one of them stuck the tip of a shovel into the side of the head and set out marching along the road waving this flag." That scene is described in chapter 10 (which is in fact titled "The Flag") and is immediately followed by a variation, this one set in Rome, near the Capitol: a man is shouting for joy at the arrival of the American tanks; he slips; he falls; a tank rolls over him; he is laid on a bed; all that's left of him is "a skin in the shape of a man"; "the only flag worthy to fly from the tower of the Capitol."

9. *A New Europe* In Statu Nascendi

The new Europe as it emerged from World War II is caught by *The Skin* in complete authenticity, that is to say

caught by a gaze that has not yet been revised (or censored) by later considerations and that therefore shows it gleaming with the newness of its birth instant. I'm reminded of Nietzsche's idea: the essence of a phenomenon is revealed in the instant of its genesis.

The new Europe is born of an enormous defeat unparalleled in its history; for the first time, Europe has been vanquished, Europe as Europe, the whole of Europe. First vanquished by the madness of its own evil incarnated in Nazi Germany, then liberated by America on the one hand, by Russia on the other. Liberated and occupied. I say this without irony. These words—both of them—are accurate. And in their juncture lies the unique nature of the situation. That resisters (partisans) had fought the Germans everywhere made no difference to the essential fact: no country in Europe (Europe from the Atlantic to the Baltic) was liberated by its own doing. (No country at all? Well, Yugoslavia. By its own army of partisans. Which is why Serb cities had to be bombarded for many long weeks in 1999: in order to impose, a posteriori, the "vanquished" status on even that part of Europe.)

The liberators occupied Europe, and the change was immediately clear: the Europe that only the day before still (quite naturally, quite innocently) considered its own history, its culture, to be a model for the entire world now felt how small it was. Here was America, shining, omnipresent; now rethinking and reshaping relations with it became the prime task for Europe. Malaparte saw that and described it without claiming to predict Europe's political future. What fascinated him was

the new *way of being* European, the new *way of feeling* European, which from then on would be determined by America's ever more intense presence. In *The Skin* that new way of being emerges from the gallery of portraits—brief, succinct, often droll—of the Americans in Italy at the time.

No position is taken, either positive or negative, in these sketches, which are often wicked, often full of sympathy: Mrs. Flat's arrogant idiocy; Chaplain Brown's sweet dumbness; the likeable simplicity of General Cork who, for the opening dance of a grand ball, instead of honoring one of the great ladies of Naples, takes as his partner the coat clerk's pretty daughter; Jimmy's friendly, appealing vulgarity; and, of course, Jack Hamilton, a true friend, a beloved friend.

Because at the time America had never lost a war, and because it was a country of believers, its citizens saw its victories as divine will confirming their own political and moral certainties. A European, weary and skeptical, defeated and ashamed, could easily be dazzled by the whiteness of those teeth, that virtuous whiteness "that every American, as he steps smiling into his grave, projects like a final salute to the world of the living."

10. Memory Turned into a Battlefield

ON THE GREAT STAIRCASE OF A NEWLY LIBERATED FLOREN-tine church, a group of Communist partisans is executing some young (even very young) Fascists, one by one. A scene that announces a radical turn in the history of European life: the victor

having drawn definitive and untouchable frontiers, there will be no more slaughters between European nations; "war was dying now, and massacres among Italians were beginning"; hatreds withdraw to the interior of nations; but even there the struggle changes its nature: the goal of the fight is no longer the future, the next political system (the victor has already decided what the future would look like), but the past; the new European war will play out only on *the battlefield of memory*.

In *The Skin*, when the American army is already occupying northern Italy, partisans execute a local informer in total security. They bury him in a meadow and, as a monument, they leave his foot, still in its shoe, sticking up from the earth. Malaparte sees this and he protests, but in vain; the partisans are delighted at leaving the collaborator as a ridiculous laughingstock in a warning for the future. And today we know: the further Europe moved away from the end of the war, the more it proclaimed it a moral duty to keep past crimes unforgotten. And as time went on the courts were punishing older and older people, whole regiments of denouncers were beating the bushes of the forgotten, and the battlefield stretched into the cemeteries.

In *The Skin*, Malaparte describes Hamburg after the Americans dropped phosphorus bombs. To quench the fire devouring them, the inhabitants were flinging themselves into the canals that crisscross the city. But the fires drowned by the water immediately flared up again in the air, so people had to keep plunging their heads under again and again; this situation went on for days, during which "thousands of heads would emerge from the water, blink their eyes, open their mouths, speak."

Another scene where the reality of war surpassed the plausible. And I ask myself why the managers of memory have not made that horror (that dark poetry of horror) into a sacred memory? The memory war rages on only among the defeated.

11. As Background, Eternity, Animals, Time, the Dead

"I never loved a woman, a brother, a friend as I loved Febo." Amid so much human suffering, the story of this dog is far from being a mere episode, an interlude in the midst of a drama. The American army's entry into Naples is only a brief second in history, whereas animals have accompanied human life since time immemorial. Facing his neighbor, man is never free to be himself; the power of the one limits the freedom of the other. Facing an animal, man is who he is. His cruelty is free. The relation between man and animal constitutes an eternal background to human life, a mirror (a dreadful mirror) that will never leave it.

The time span of the action in *The Skin* is short, but man's infinitely long history is always present in it. It is through the *antique* city of Naples that the American army, the most *modern* army of all, enters Europe. The cruelty of a supermodern war plays out before the background of the most ancient, archaic cruelties. The world that has changed so radically makes clear, at the same time, what remains sadly unchangeable, unchangeably human.

And the dead. In peaceful times they only modestly interrupt

our tranquil lives. But in the period described in *The Skin*, they are not modest; they are active; they are everywhere; undertakers haven't enough vehicles to carry them away, the dead stay on in the apartments, on the beds, they decompose, stink, they are in the way; they invade conversations, memory, sleep: "I hated these corpses. They were the *foreigners*, the only, the real *foreigners* in the common homeland of all the living."

The war's closing moments bring out a truth that is both fundamental and banal, both eternal and disregarded: compared with the living, the dead have an overwhelming numerical superiority, not just the dead of this war's end but all the dead of all times, the dead of the past, the dead of the future; confident in their superiority, they mock us, they mock this little island of time we live in, this tiny time of the new Europe, they force us to grasp all its insignificance, all its transience. . . .